BIRDS OF PREY

A PORTRAIT OF THE ANIMAL WORLD

Leonard Lee Rue III

MAGNA BOOKS

Dedicated to Uschi, who has greatly
enriched my life with her love.

This book was designed and produced by
Todtri Productions Limited
P.O. Box 20058, New York, NY 10023-1482
according to a proposal from Euredition bv, Den Haag

Editions of this book will appear simultaneously in France,
Germany, Great Britain, Italy, the Netherlands and Sweden
under the auspices of Euredition bv, Den Haag, Netherlands

This edition published by Magna Books,
Magna Road, Wigston, Leicester LE18 4ZH, England

ISBN 1 85422 488 3

Author: Leonard Lee Rue III

Producer: Robert M. Tod
Book Designer: Mark Weinberg
Editor: Mary Forsell
Photo Editor: Natasha Milne
Design Associate: Jackie Skroczky
Typesetting: EnterGraphics, Poughkeepsie, NY
Printed and Bound in Singapore by Tien Wah Press

INTRODUCTION

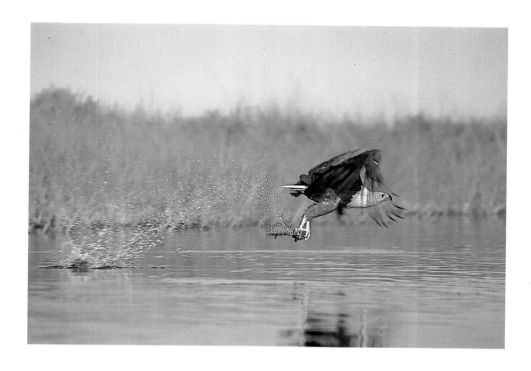

This African fish eagle has just snatched a fish that was swimming close to the surface of the water.

What is a predator?
Any creature that eats another, whether it be a lion eating a zebra, a whale eating krill, or a praying mantis eating a grasshopper.

What is a bird of prey? Though a phoebe eating a moth or a robin catching a worm both fit the definition in the broadest sense, in this book we will address the raptors specifically: hawks, eagles, and owls.

The first bird, archaeopteryx, shared the world with the giant lizards, the dinosaurs of the Jurassic period of 180 million years ago. This bird was descended from the climbing lizards, and the feathers of its wings were a form of modified scales.

The prototypes of some of the raptors first appeared in the Tertiary period, during the Eocene of fifty-eight million years ago. These were the forerunners of some of our owls and some of the New World vultures. By the Oligocene, thirty-six million years ago, Protostix owls had given way to the long-eared owls, the horned owls, the buteo hawks, the secretary birds, and some of the feather-footed eagles. Descendants of all of these birds are still with us today.

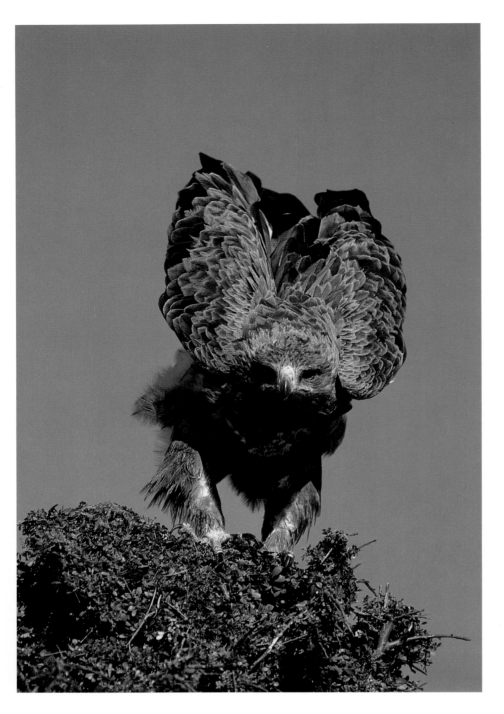

The tawny eagle is the most populous eagle of its size found throughout Asia and Africa. Although it does feed on rodents and birds, it is primarily a scavenger.

The Miocene epoch, twenty-five million years ago, was the golden age of raptors. Many kinds evolved, and they were much more numerous in both species and in populations. The Miocene witnessed the appearance of the sea eagles, the Old World vultures, the kites, the barn owls, and the falcons.

The Pliocene, twelve million years ago, saw the development of the giant condors, and the king turkey vultures of today. The largest of the condors, the teratornis, which had a wingspan of 17

feet (5 metres), did not survive to the most recent times. The present-day Andean condor is the world's largest flying bird, having a wingspan of 10 feet (3 metres).

The glacial Pleistocene down to the present time saw the development of the harriers, burrowing and screech owls, the caracara, the osprey, and the lammergeier vulture, which has a 9-foot (2.7-metre) wingspan.

Years ago, many of the hawks such as the peregrine, the gyrfalcon, the goshawk, and others were used in falconry. It was once considered the sport of kings, and only the very wealthy upper class could afford to engage in it. It is still a favoured pastime with many of the wealthiest Arab sheiks.

For centuries, most hawks and owls were persecuted wherever they were found because they preyed upon game that hunters wanted for themselves or on livestock and chickens that the farmers were attempting to raise. As a boy brought up on a farm, all I ever heard was that all hawks were chicken hawks and should be shot on sight. I shot one hawk right after I got my first gun at the age of twelve, a female marsh hawk or northern harrier. Instead of being proud of what I had done, I was so saddened that I never shot another hawk.

When I had access to reliable resource data, I learned how beneficial hawks and owls actually are. At that time some of

America's states still paid bounties on raptors. It took many more years before the general public learned what I did years ago. Finally enough people cared and enough organizations brought pressure to bear that the United States government passed laws protecting all hawks, owls, and eagles. It was almost a case of locking the barn door after the horse had been stolen. By the mid–1960s so many of America's raptors had been poisoned by government use of DDT that the laws were passed to save the remnants. Thankfully, today American raptor populations have made a steady climb back from the brink of disaster.

Man has always envied the birds for their freedom of flight. Today, the raptors are not only a symbol of freedom, they are a barometer on the health of our planet. Just yesterday the sky over my home was filled with redtails soaring south in migration. My heart and spirit soared with them as I wished them Godspeed on their journey.

These young European buzzards are ready to leave the nest. Note that the nest is a very old one that has been used for many years. It has vegetation growing on the rotted nest material.

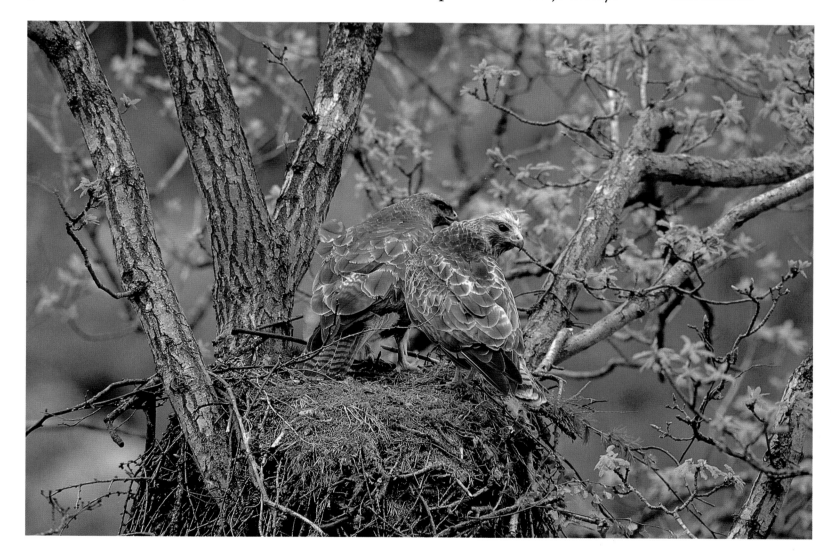

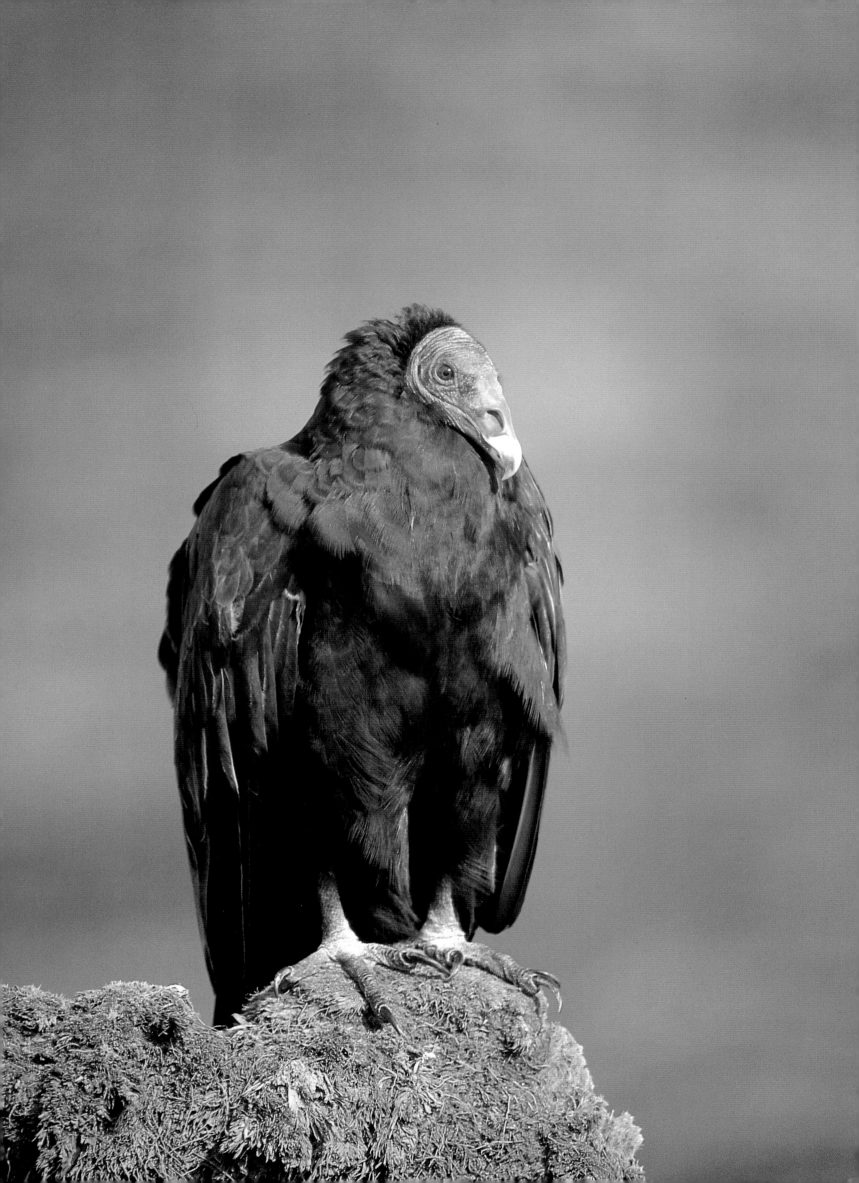

TURKEY VULTURE

The turkey vulture *(Cathartes aura)* has a wingspan of about 72 inches (1.8 metres). In flight, the wings are bent upward (dehydral), forming a shallow V. It has a bare red face and head with a corrugated, or ridged, nape and dark amber eyes. Immature birds have a dark grey face and head. The bird's basic plumage is a very dark brown with a tendency to iridesce.

This bird has a very large range that extends from southern Canada throughout all of the United States, Mexico, Central America, and most of South America, all the way down to Tierra del Fuego. Most of the birds in the northern part of this vulture's range migrate to the south, some going as far as South America.

Turkey vultures often roost in large numbers, except for the breeding season, when they pair up. They usually prefer to roost in dead trees. Sometimes the weight of their numbers breaks the dead limbs from the tree.

Feeding primarily on carrion, this is one of the few birds that has a well-developed sense of smell. Although it has keen eyesight, the turkey vulture can locate food by odour alone.

The vultures usually roost in dead trees and preferably on a hillside where the thermals coming up the hill will give them extra 'lift' in the morning when they are ready to fly. Vultures usually sit in the tree with their wings outstretched in the early morning, sunning, and waiting for the earth to warm up and the thermals to rise, so that they can soar.

Although its diet is comprised almost entirely of dead birds, animals, fish, and the like, it has been known to kill newborn pigs and baby herons and ibis in rookeries.

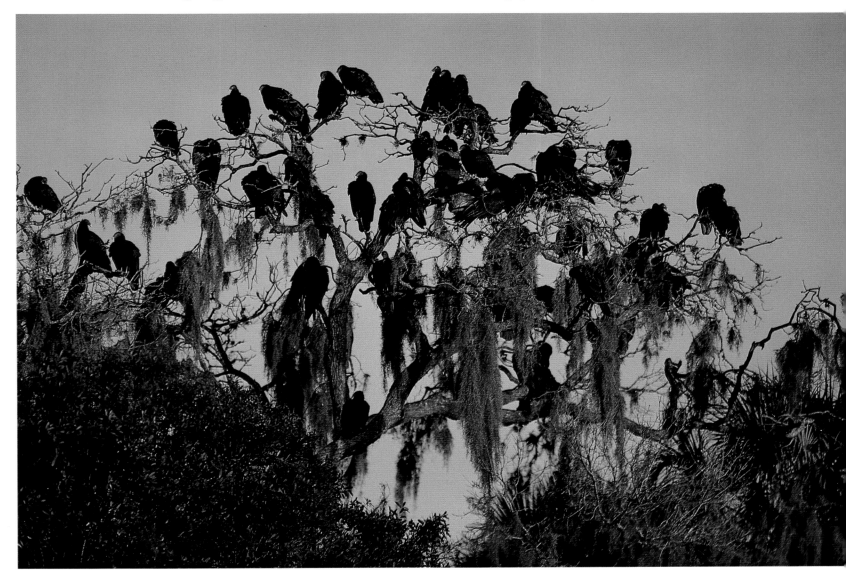

The turkey vulture gets its name because its bare red head resembles that of the adult male wild turkey.

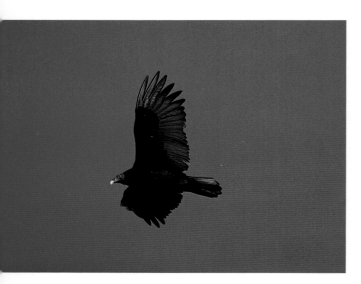

Turkey vultures locate the dead creatures that they feed on by both sight and odour as they soar above the countryside.
The vultures are some of the very few birds that have a well-developed sense of smell.

BLACK VULTURE

The black vulture *(Coragyps atratus)* is slightly smaller in wing size than the turkey vulture, having a wingspan of about 60 inches (1.5 metres).

The black vulture has a basically black colouration although it has patches of white in its underwing pinions. Its naked face and head are black with the nape wrinkled. Its eyes are brown and its tarsus and feet are greyish black. In flight it can be recognized by its white wing patches and its short, squared tail.

The bird is slowly expanding its range and can be seen in increased numbers in northwestern New Jersey. At one time they were exceedingly rare; today they are becoming quite common. Their range extends southward through Mexico, Central America, and the northern two-thirds of South America.

Although the turkey vulture is sociable, the black vulture is gregarious, often being seen in large numbers. They are much more aggressive, fighting viciously among themselves over food.

The black vulture has a corrugated hood and cowl. It has the "see–through" nostrils typical of the New World vultures.

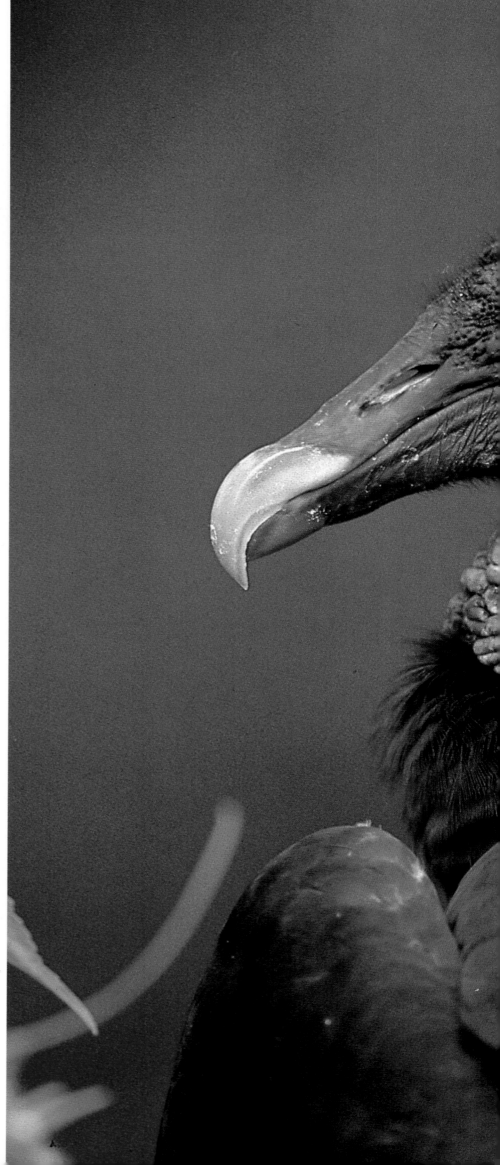

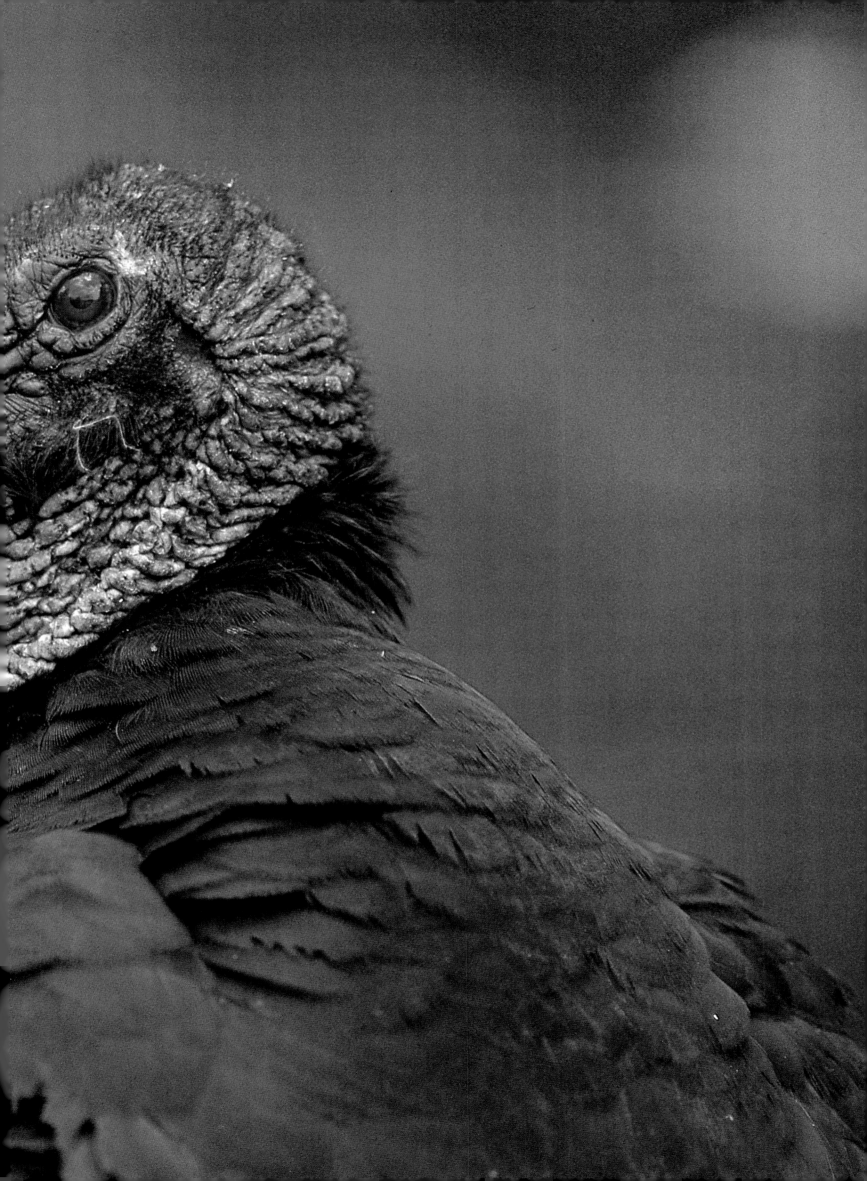

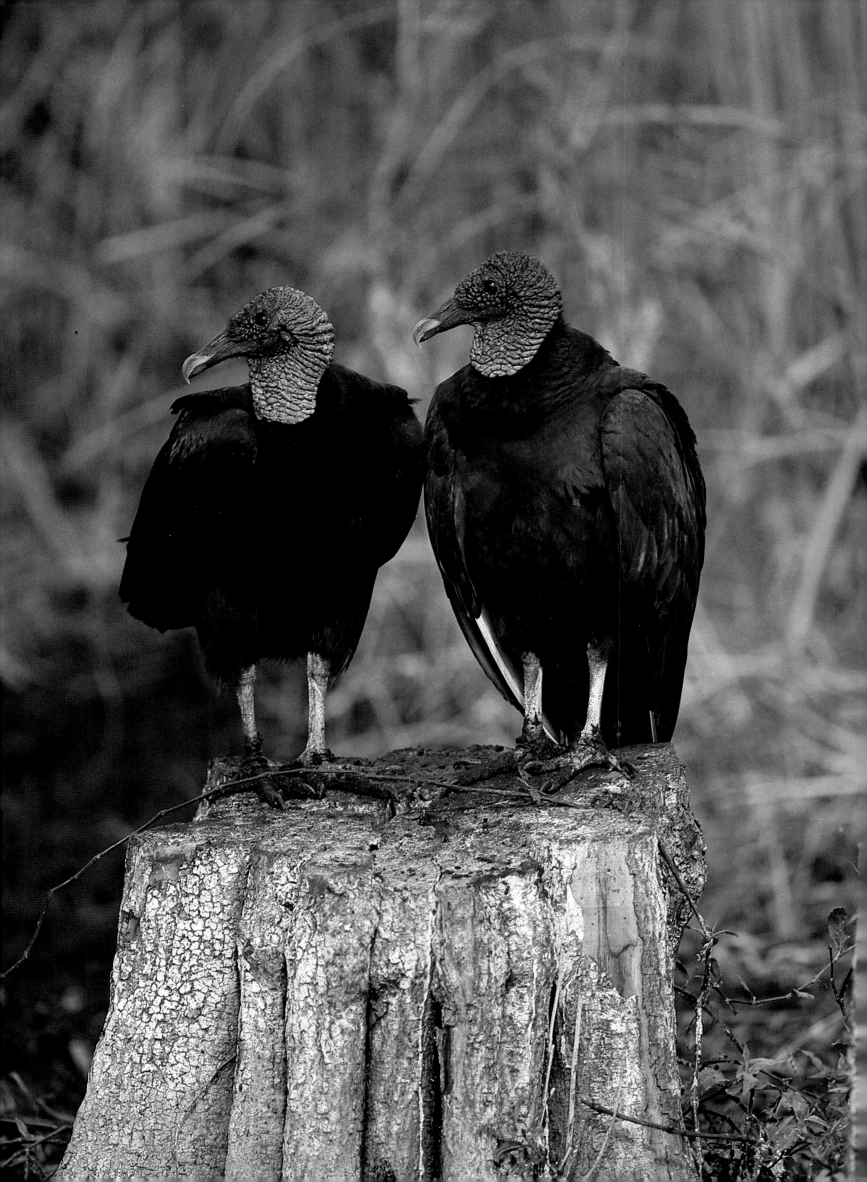

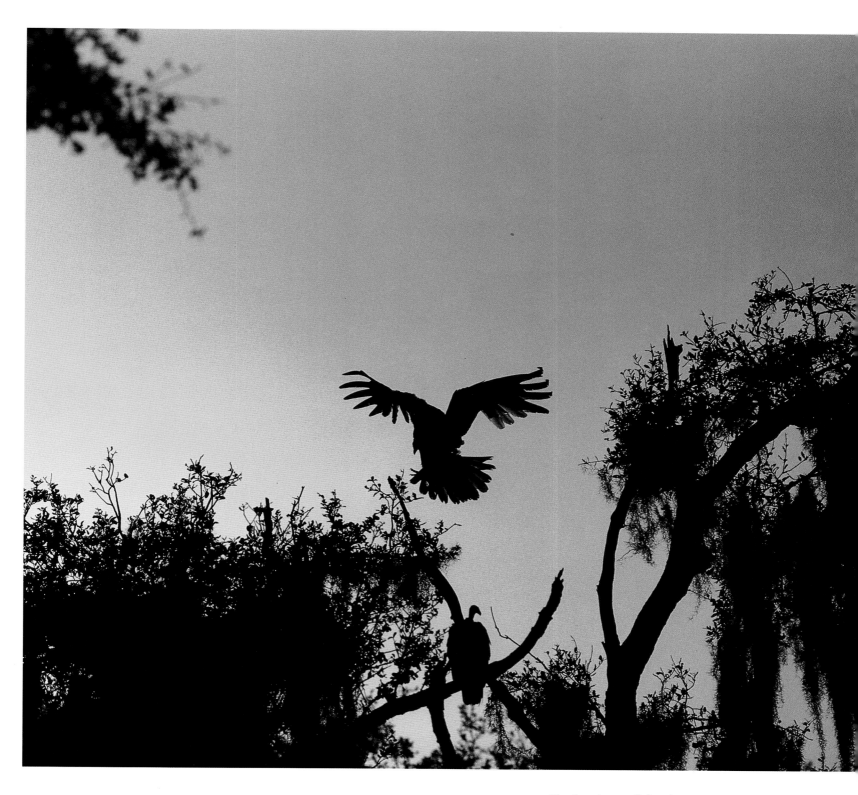

The feathers of the black
vulture are a dark brownish
black. They do not iridesce
like those of the turkey vulture.

Black vultures flying in to roost
for the night. The actual time of
their roosting occurs when the
earth cools off so it is no longer
sending up warm thermals of air.

CALIFORNIA CONDOR

The California condor *(Gymnogyps californianus)* is a relic left from millions of years ago. There are no condors living in the wild today. The remaining few condors were live–trapped a number of years ago and were used in a breeding programme that has been very successful. At this writing, eight young condors have been raised that are ready to be returned to the wilderness area that was their former home.

The condor is the largest bird in North America, having a bill–to–tail–tip length of up to 55 inches (1.4 metres). Its wingspan is about 114 inches (2.8 metres) and it weighs from 25 to 30 pounds (11.25 to 13.5 kilograms). It soars at a speed of 35 to 40 miles (56 to 64 kilometres) per hour.

Like the other vultures, the male and female look alike. Their basic body plumage is black, although there is a white line in each of the underwings. The head skin is an orange colour, and they have a purplish red patch of skin in the lower neck. Their bills are white, their eyes are red, and their tarsi and feet are pink.

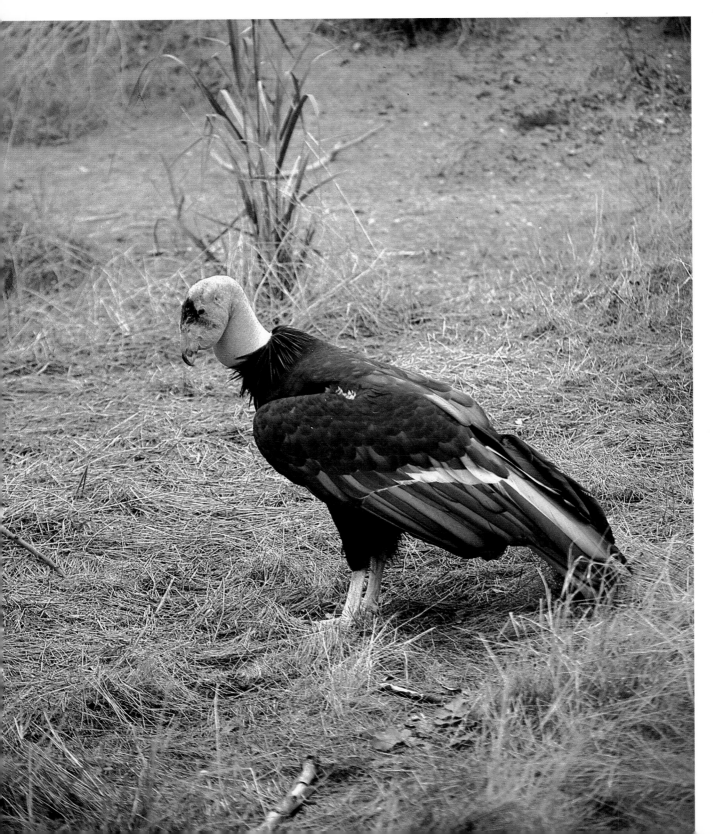

The California condor is no longer found in the wild. The surviving condors were live-trapped a few years ago in an effort to artificially propagate this species in captivity. The program has been a success, and eight young condors are almost ready to be released into the wild.

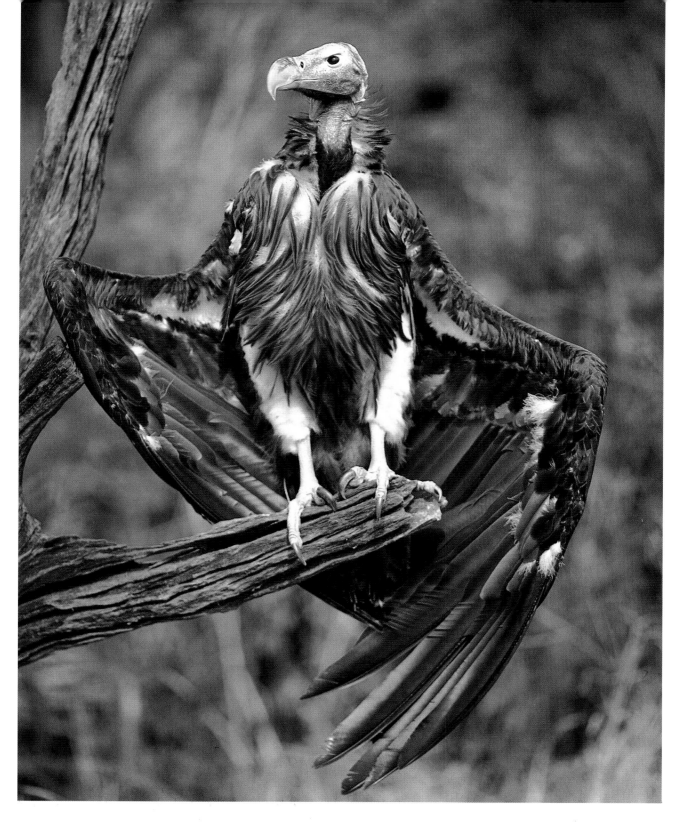

The lappet-faced, or Nubian, vulture is one of the largest found in Africa. Like all vultures, it often sits in the early morning sun with outstretched wings, waiting for the earth to warm sufficiently to send up thermals on which it can fly without flapping.

Thousands of condors lived over the Rocky Mountains many years ago. The young birds will be returned to the same area of southern California, from Fresno south to Fillmore, from whence the last wild condors were trapped. This is a region of rugged canyons, steep cliffsides, and forested mountains.

The condor feeds exclusively on carrion; there is no record of them ever attacking a living creature of any kind.

LAPPET-FACED VULTURE

This vulture *(Torgos tracheliotus)* is named for the large, bare lappets of skin that hang from below the ear down the neck. Its basic body feathering is a deep brown, but many of the feathers are edged in light brown. The tail is black and wedge shaped. The bill is black, the eyes are dark, and the skin of the face and the top of the head is yellow-orange. A heavy fold of skin runs down each side of the bare head to the lappets, and there is a white line running just behind the leading edge of the underside of the wing. The tarsus and feet are blue-grey.

This vulture has a wingspan of about 108 inches (2.7 metres). It weighs up to 25 pounds (11.25 kilograms). The range of the lappet-faced vulture extends across northern Africa from the Atlantic to the Red Sea, south along the Indian Ocean and across the tip of South Africa.

Despite their large size, these vultures are seldom the first to feed at a carcass. I have

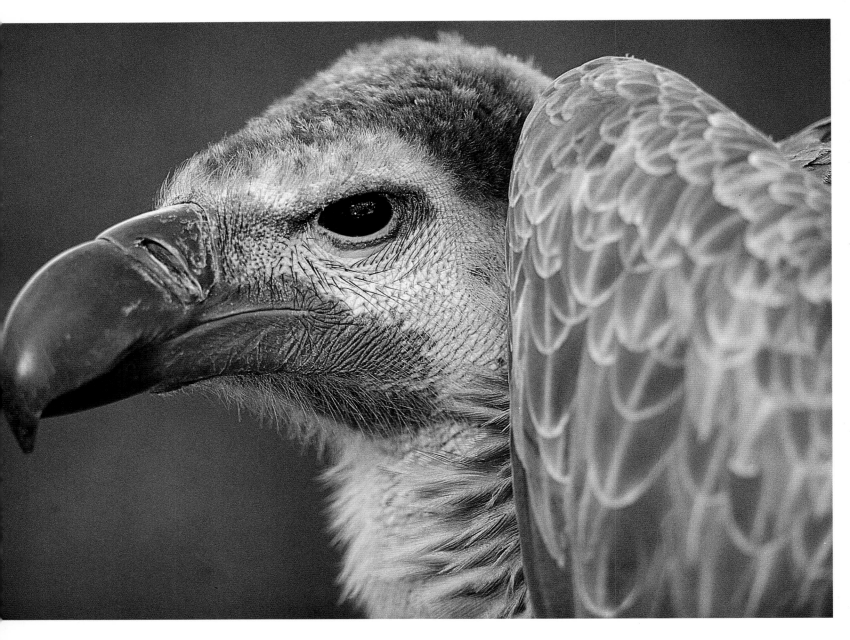

watched them many times sit at a distance from the carcass while the other species of vultures swarmed all over it. After fifteen to twenty minutes, a pair of lappet-faced vultures, with drooping wings, would stride into the midst of the melee, chasing all of the other vultures before them.

AFRICAN WHITE-BACKED VULTURE

The white-backed vulture *(Africanus pseudogyps)* has a wingspan of about 85 inches (2 metres). The white area of the bird's lower back is not visible unless its wings are outstretched. 'White–winged vulture' would have been a better name because it is the white underlining of the bird's wing, framing the dark primary and secondary feathers, that is the identifying characteristic of this bird in flight.

This vulture has a dark bill, dark eyes, and short white feathers on its head and neck. The base of the neck has a small ruff of white feathers. Its basic belly, tail, and wing feathers and upper back are various shades of brown. These vultures are at home over the lower two-thirds of Africa, except in the west coast forested areas and the tip of the Cape of the Hope. They are birds of the open plains or steppes, where they follow the migrating herds of big game animals. The white-backed vultures are the most common vulture in all of Africa.

Although white–backed vultures have large bills, they are not capable of cutting through the thick hides of an elephant or hippopotamus. The birds feed only on prey that has died or been killed. They soar at heights of up to 2,000 feet (606 metres), each one watching all the other vultures. When one vulture finds food, its descent pulls in vultures from a vast area. I once saw a flock of vultures pull a 350–pound (157–kilogram) waterbuck over the ground as they fed upon it.

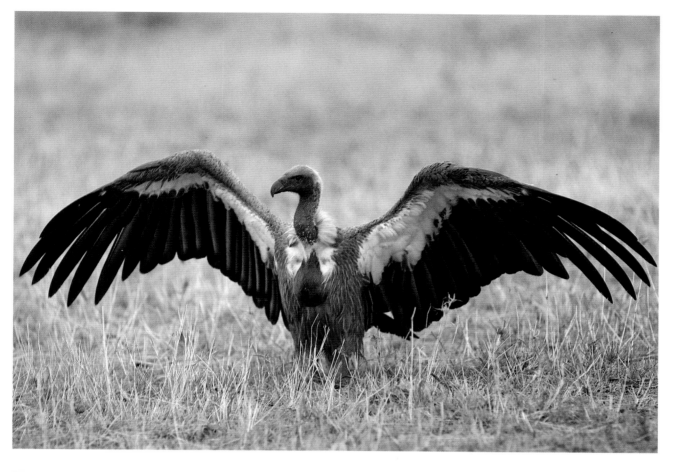

White-backed vultures often sit on the ground or in a tree with their wings outstretched, "sunning." They are usually waiting for the ground to warm up to create the thermals that will lift them effortlessly into the sky.

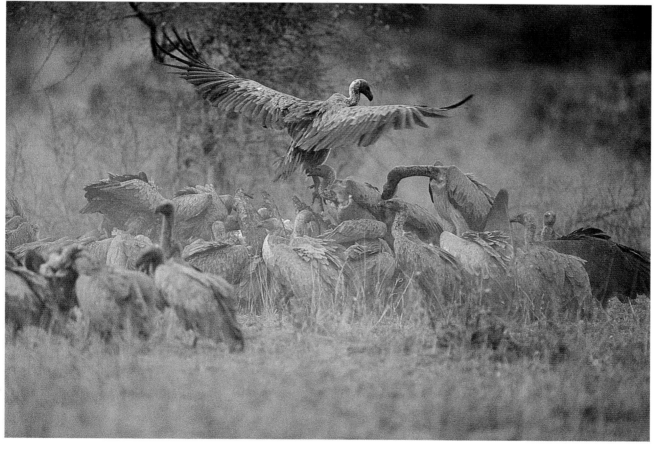

The white-backed vulture is the most commonly seen vulture in all of Africa. It is not unusual to see as many as two hundred or more of these birds gathered to feed on a big carcass.

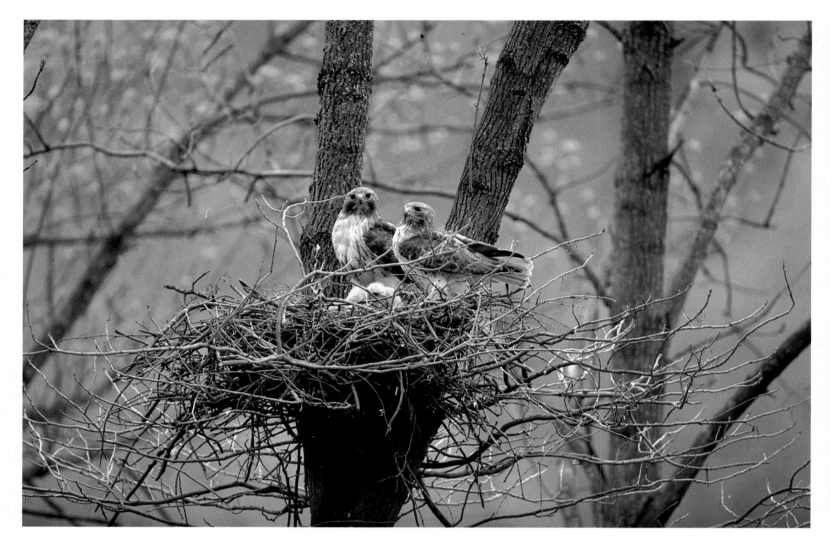

RED-TAILED HAWK

The redtail *(Buteo jamaicensis)* has three different colour phases. In the eastern half of the United States, it has a white breast with a dark bellyband. Farther west it may have a reddish belly and, in the dark phase, the breast and belly may be dark brown. In all phases the upper tail colouration will be a rich rusty red with a light brown undersurface. The top of the head and the back are a light to dark brown in the eastern phase and red or brown in the western phases. The redtail has brown eyes and yellow tarsus and feet.

The female of the redtail is larger than the male, which is true of most hawks, falcons, and eagles, but not of the vultures. An adult redtail will have a wingspan of 48 to 58 inches (1.2 to 1.5 metres).

The redtail has a very extensive range and is found in more types of habitat than any other hawk. It ranges from southern Alaska to James Bay to the Atlantic Ocean south, including all of Central America. The hawks do migrate from the most northern reaches of their range, but stay put over most of the United States. In fact, redtails are the most common and most often seen hawk in America. In flight, the tail shows conspicuously each time the hawk banks into a circle. They also hunt for their prey by perching in a tree for hours on end and are then most usually identified by their dark belly bands.

Mice and rats are probably their main food item, but they also eat large numbers of both tree and ground squirrels. Rabbits, young marmots, small birds, game birds, snakes, shorebirds, wading birds, frogs, salamanders, and even insects may be eaten. The redtail used to be known as a chicken hawk, but modern farming practises, by which chickens are raised inside, has made this a thing of the past.

A red-tailed hawk family portrait. Notice how much larger the female is than the male. The chicks are a little over one week old. The large, bulky nest is about 40 feet (12 metres) from the ground.

The red-tailed hawk, in its several colour phases, is the most commonly seen large buteo hawk. It typically perches out in the open on some conspicuous dead snag while it waits for its prey to betray its presence.

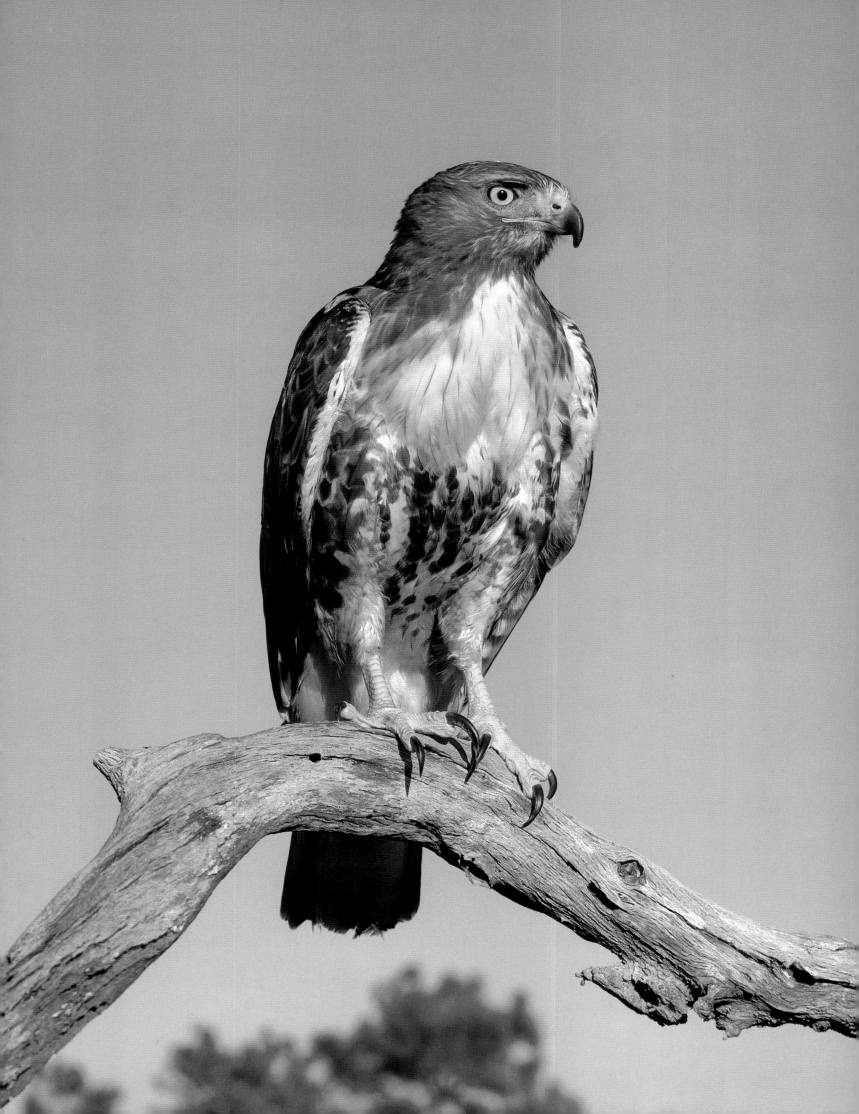

The red-tailed hawk is the most frequently seen soaring hawk in the United States. Since laws have been passed protecting all hawks, eagles, and owls in the United States, population has increased even more. They are a very common sight perched in trees along the highways, where they hunt for mice.

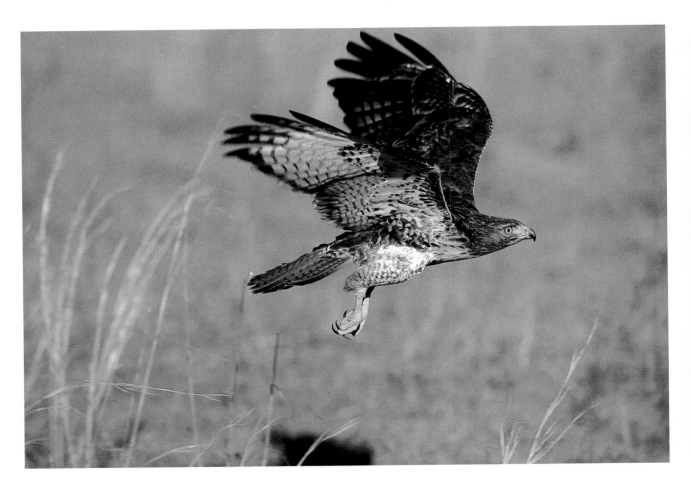

Red-tailed hawks do not usually carry off the prey they kill, but eat it right on the spot. This hawk fed intermittently on a duck kill for a period of six days.

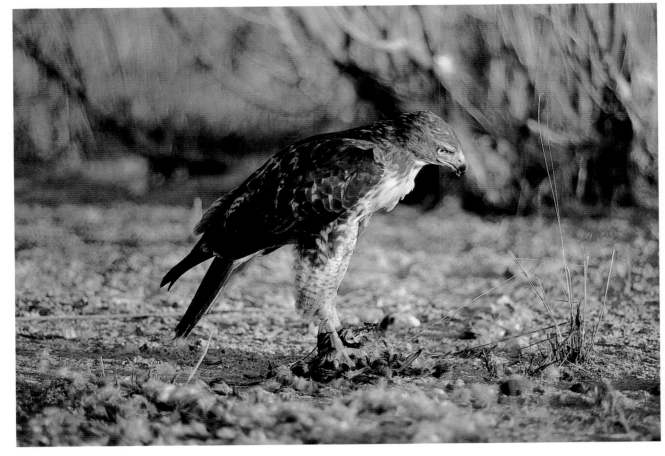

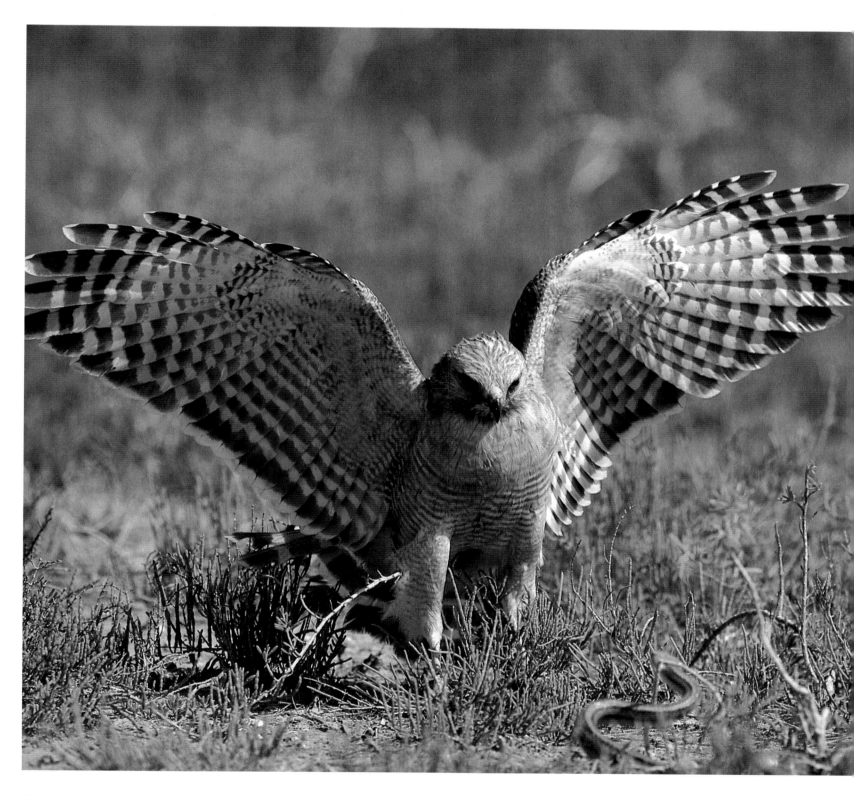

This red-shouldered hawk is trying to kill
a yellow rat snake. Although the rat snake
is not a poisonous snake, this hawk does
not hesitate to kill the poisonous ones as well.

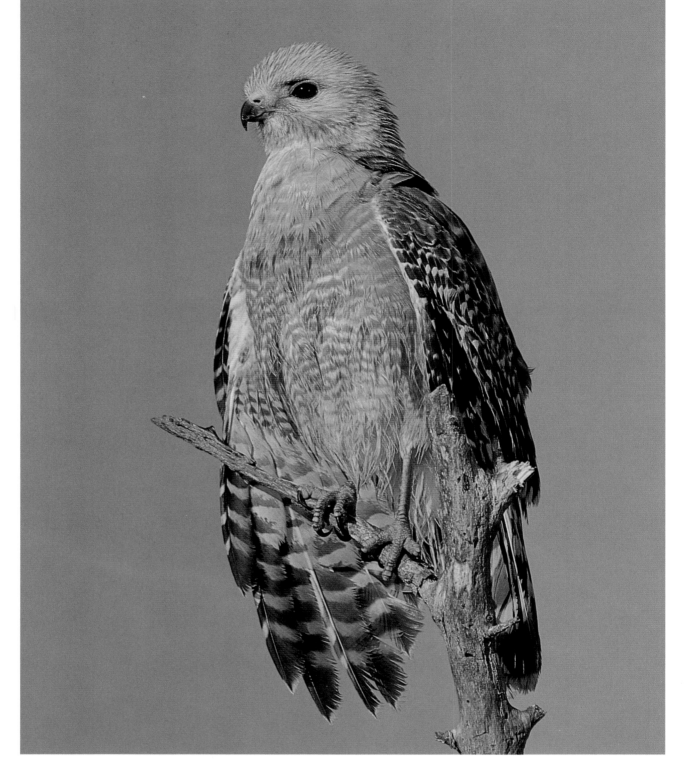

You can easily see why the red-shouldered hawk is often called the red-bellied hawk in some parts of the United States. These hawks vary in colouration from very light to very dark.

RED-SHOULDERED HAWK

The red-shouldered hawk *(Buteo lineatus)* has a wingspan of 35 to 50 inches (88 to 125 centimetres). The female is larger than the male.

This hawk has a brown back; its breast and belly are light with heavy red and brown barring. It gets its name from the red patches on its shoulders which, in some birds, are very difficult to see. There are six to seven narrow white bands on its dark tail.

The red-shouldered hawk ranges on the North American continent from Manitoba east to Maine, south to Texas, old Mexico, and Florida. One subspecies is found along the Pacific coast from California up to Washington. This subspecies is often called the red-bellied hawk. The birds migrate to the south in winter.

This is a hawk of woodlands and low-lying areas. It feeds heavily on snakes, frogs, lizards, and salamanders as well as mice, rats, and other small rodents. It also eats some insects. Squirrels are part of their staple diet.

BROAD-WINGED HAWK

The broad-winged hawk *(Buteo platypterus)* is the smallest of the North American buteos. The broadwing, the red-shouldered, and the redtail are the three soaring hawks most commonly seen.

The adults have a wingspan of 32 to 39 inches (81 to 99 centimetres) and weigh about 1 pound (.45 kilogram). The birds have a dark brown back; the underparts are white with a rusty red barring. The underwing surfaces are white, the tail has three bands of white and three bands of black.

This North American bird's range extends from Minnesota east to Maine and south to Texas and Florida. The birds in the northern tier of states migrate south in the winter along well-known mountain routes.

It is basically a woods hawk that feeds in clearings on such animals as frogs, toads, snakes, chipmunks, young rabbits, mice, and insects. Its small size does not allow it to catch animals larger than a squirrel.

The broad-winged hawk, shown here with its young, is a very common small buteo, or soaring hawk, in North America. It is one of the earliest birds to migrate southward, passing down the eastern mountain range by the thousands in the month of September.

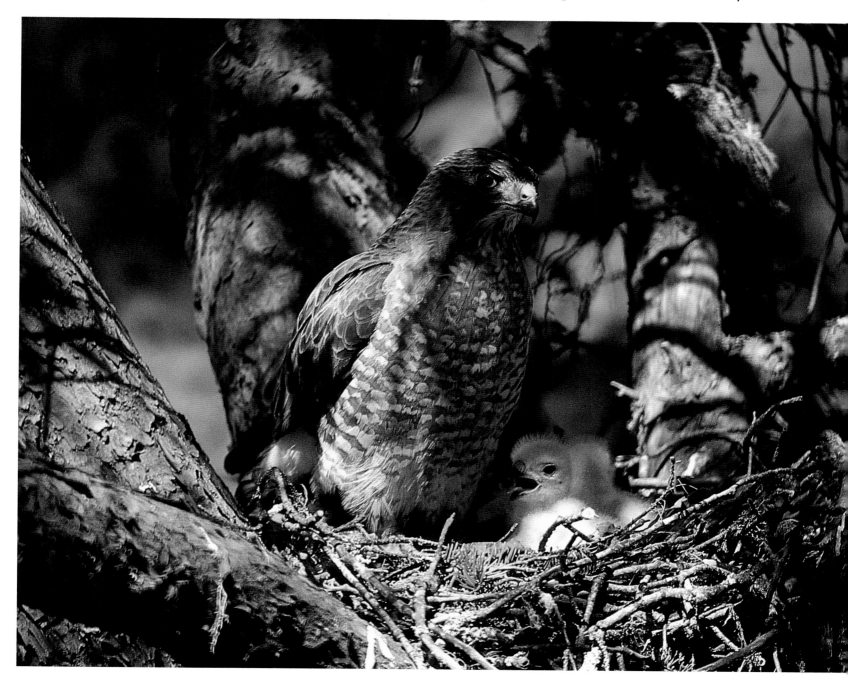

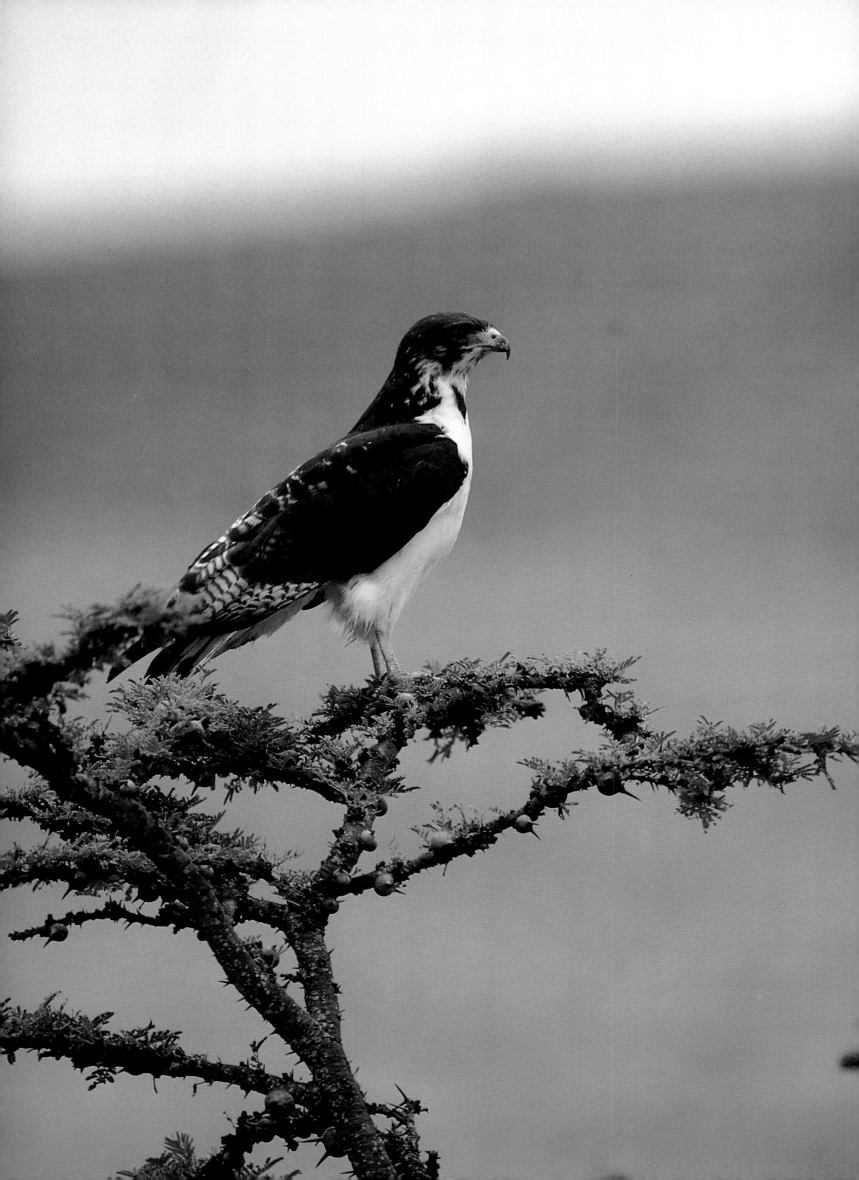

AUGUR BUZZARD

The augur buzzard *(Buteo rufofuscus)* is a common buteo of Africa. In east Africa, the subspecies is brown on all of the upper parts and white below. In South Africa the subspecies is basically black all over, although the primary and secondary feathers are light when seen from below. It has a wingspan of 47 to 53 inches (1.1 to 1.3 metres).

Native to east, east–central, and South Africa, the bird does not migrate. I have found that this hawk does most of its hunting while perched rather than by soaring. In the dry thorn bush of east Africa, it will usually be found in the open trees along the waterways. It feeds upon snakes, small birds, game birds, rodents, and insects. The augur buzzard also feeds upon the carcasses of animals killed on the road and is often killed itself when it cannot get out of the way of a speeding vehicle.

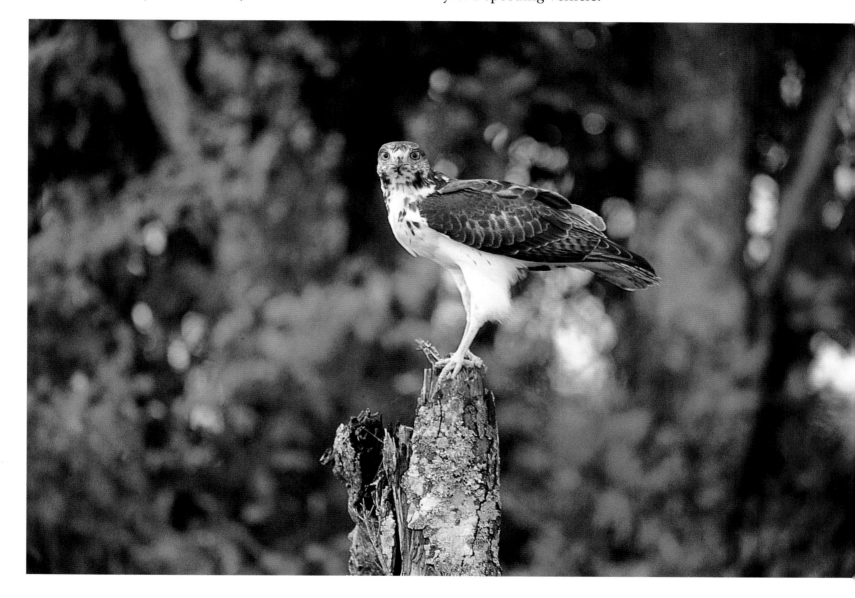

There are several different colour phases of the augur buzzard. The most common white-bellied phase is the one usually seen in east Africa.

The augur buzzard is probably the most commonly seen buteo hawk in Africa. It is the counterpart of the North American red-tailed hawk.

This peregrine is "mantling" over the bird it has killed. The falcon has already torn its prey's head off. The bird will pluck the feathers from its prey before it eats it.

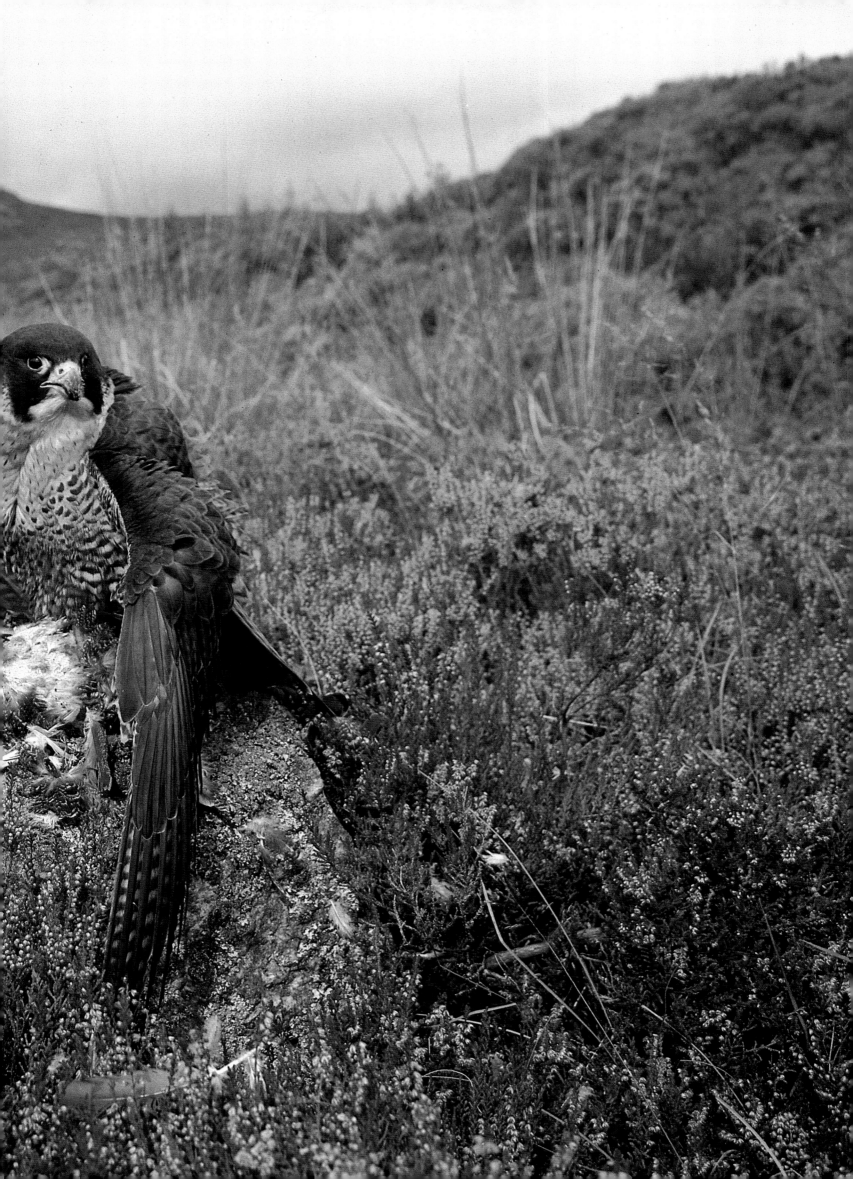

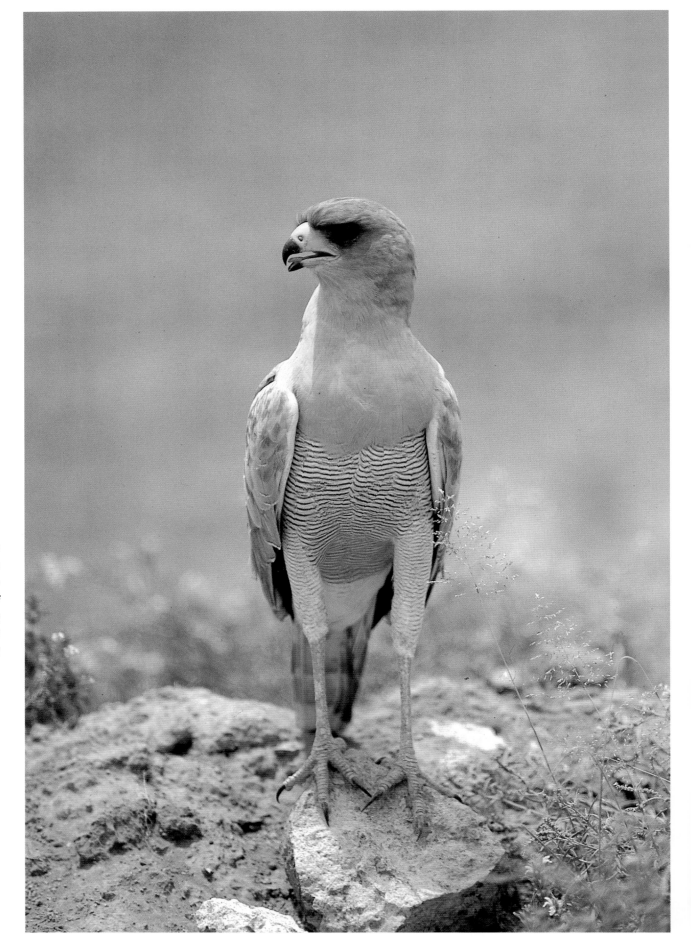

The pale chanting goshawk is an accipiter found in the brushlands of east Africa, where it feeds upon small rodents, small birds, and snakes.

GOSHAWK

The largest of North American woods hawks, the goshawk *(Accipiter gentilis)* has a wingspan of 40 to 47 inches (1 to 1.1 metres). The goshawk has a blue-grey crown, a very distinctive white eyebrow stripe, and an orange-red eye. The throat, breast, and belly are white with grey speckles.

Its summer range extends from the northern tier of the United States across Canada as far north as the tundra regions. In the winter time, the northern goshawks migrate south to stay in the northern third of the United States. The bird will be found only in the forested regions.

The short, cupped wings of this hawk allow it to reach a high speed in a very short time. Then, on set wings, it bullets through the trees and underbrush at speeds of up to 35 miles (56 kilometres) per hour.

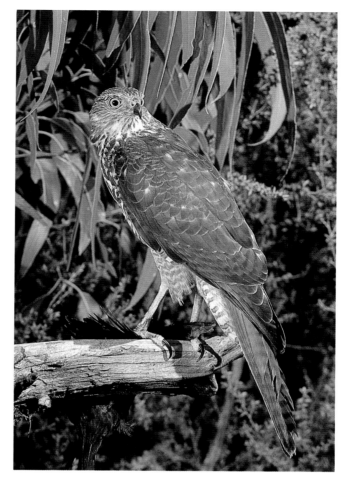

The brown goshawk is a bird of Australia and the western Pacific islands. It feeds mainly upon small to medium–sized birds, small mammals and, occasionally, upon snakes.

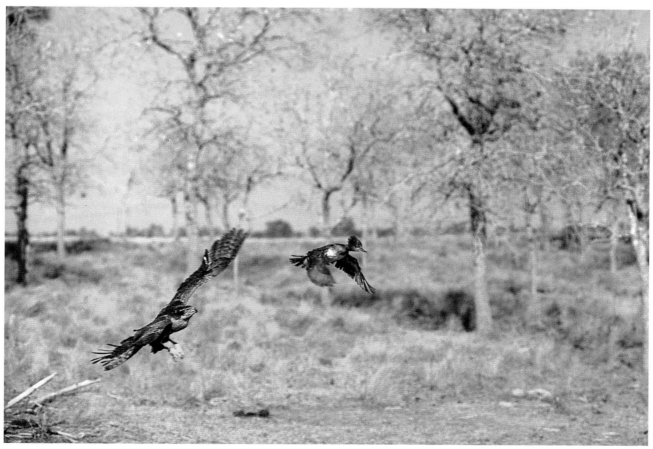

This northern goshawk of North America is a woods hawk that has short, cupped wings and a long tail. Its cupped wings allow it to reach a high speed very quickly, enabling this bird to over-take and catch this female hood ed merganser.

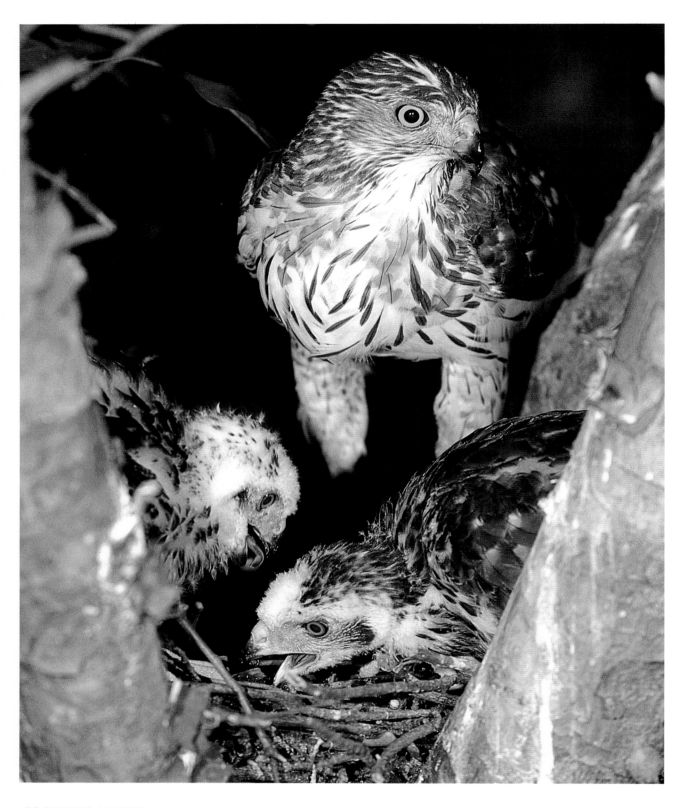

This Cooper's hawk has just brought a prey animal to its young. The young hawks are large enough to tear the prey apart by themselves.

COOPER'S HAWK

I first knew the Cooper's hawk (*Accipiter cooperi*) as the 'big blue darter'. It is a woods hawk that flies through the brush at up to 55 miles (88 kilometres) per hour. The bird's upper parts are a deep slate blue, while underneath it is a basic white with heavy rust red barring. The birds have a wingspan of 27 to 36 inches (68.6 to 91 centimetres). The tail is white with four narrow black stripes and one wide one. The corners of the tail are rounded.

It is easy to confuse a small male Cooper's hawk with a large female sharp-shinned hawk. However, the sharp-shinned hawk's tail is squared at the end. Its nesting range extends from the northern third of the United States up to the Canadian tundra region. It migrates south, wintering over the entire United States.

This hawk is a haunter of the woodlands, hunting in the open only if such openings are in, or adjacent to, wooded areas. It usually sits concealed by foliage or up against a tree trunk. It feeds mainly upon small to medium–sized birds, chipmunks, mice, and red squirrels. In attacking birds it will launch its attack and often snatch the bird out of the air with just one foot.

The Cooper's hawk is a bird of the woodlands, where it feeds upon small birds, rodents up to the size of squirrels, and game birds. It has short, cupped wings, which allow the hawk to launch a swift attack from a hidden perch.

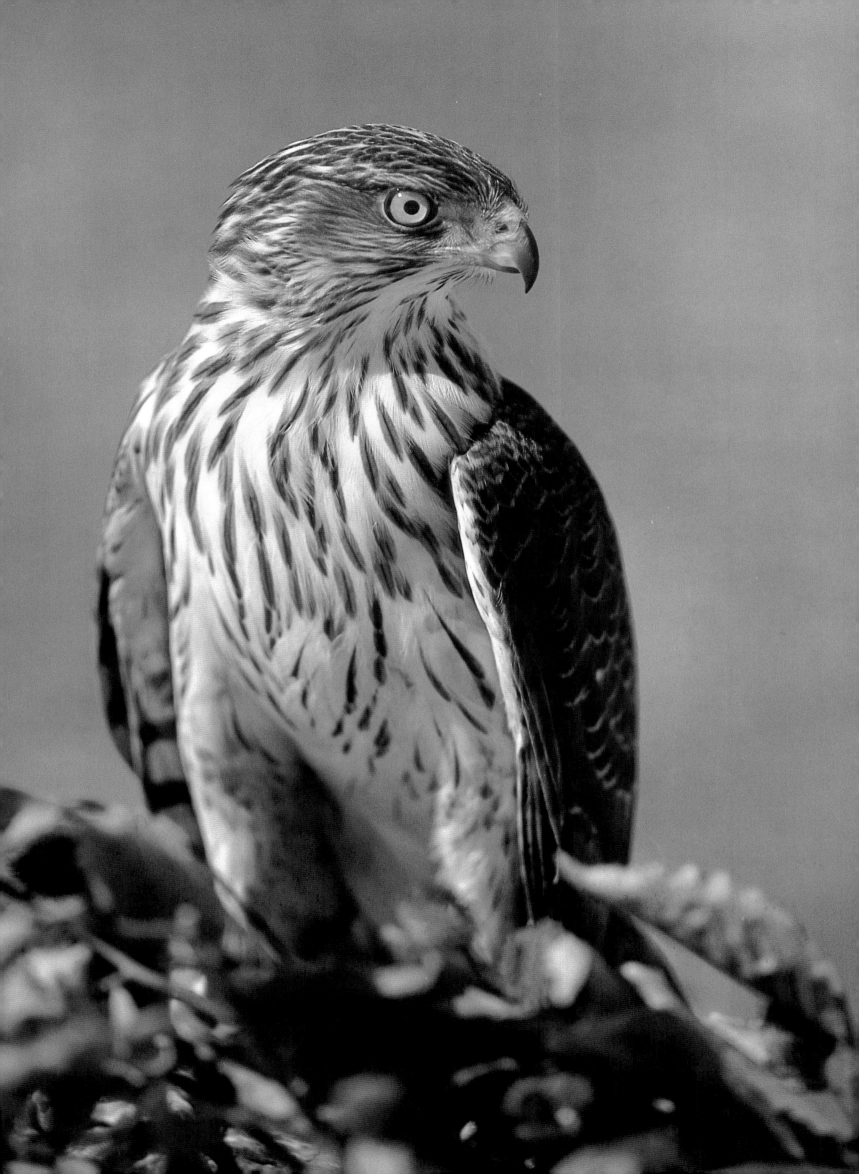

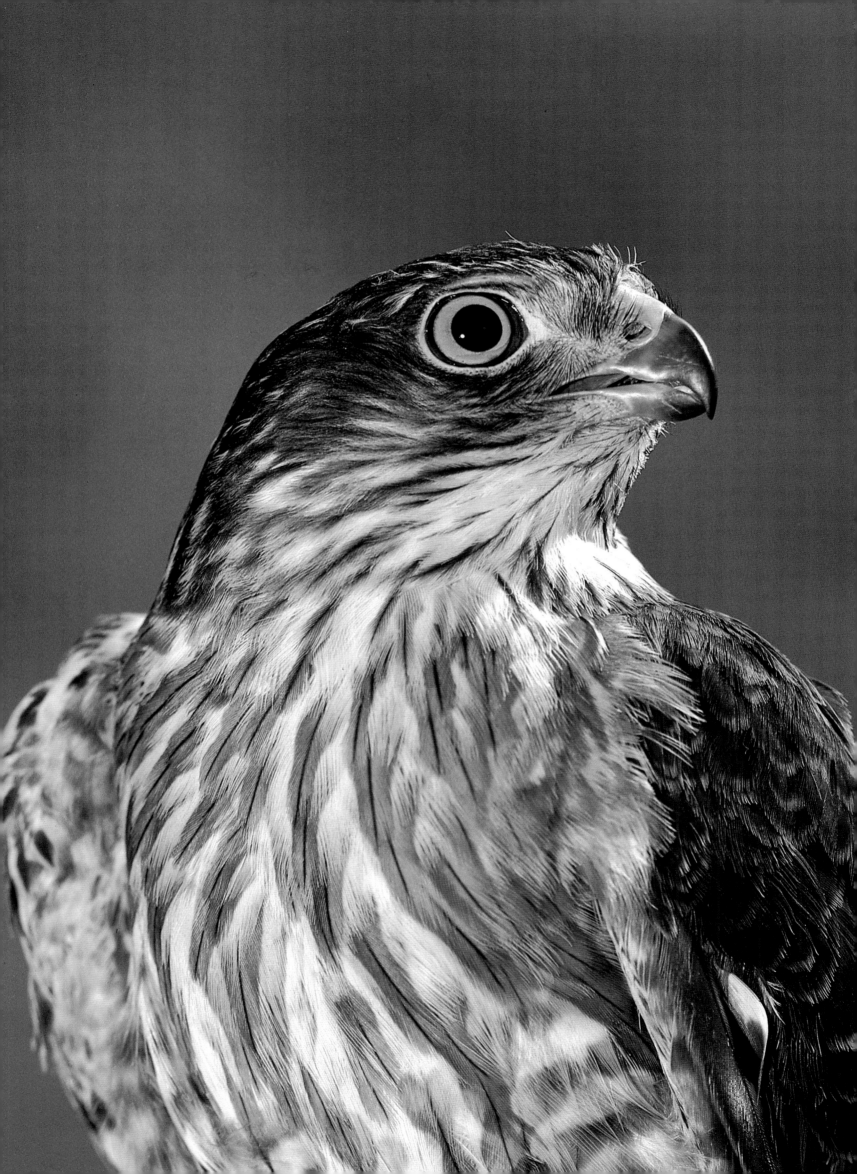

SHARP–SHINNED HAWK

The sharp-shinned hawk *(Accipiter striatus)*, or 'little blue darter', is just a smaller edition of the Cooper's hawk. It, too, has the dark slate blue upper parts with its white under areas heavily barred with rust red. It has red eyes and yellow feet and has a wingspan of 20 to 27 inches (50 to 68.6 centimetres).

Its breeding range extends from the northern United States up to the Canadian tundra. It migrates to the southern two-thirds of the United States. The sharpshin is the most common hawk to come in to my bird feeding area. Its main food consists of the small songbirds up to the size of bluejays, which it frequently eats.

If the sharpshin misses all the birds on its first pass over the feeders, it often sits in a tree waiting for some bird to venture out of hiding. This seldom happens; most birds are caught in midflight while scattering on the initial dash by the hawk through the area.

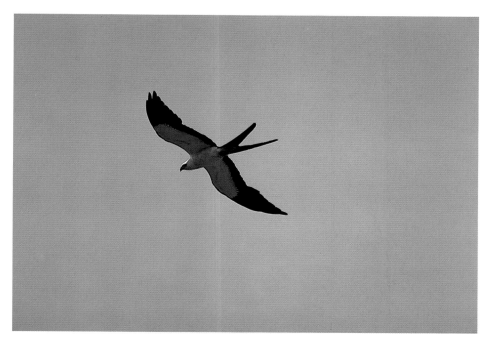

SWALLOW-TAILED KITE

There is no mistaking a swallow-tailed kite *(Elanoides forficatus)* when you see one. The bird is pure white on its head, neck, breast, belly, and the leading edges of its wings. Everything else, including its long, deeply forked tail is jet black. The birds are 19 to 25 inches (48 to 63 centimetres) in overall length and have a wingspan of up to 50 inches (1.3 metres).

This bird is found all along the Gulf Coast of the United States and up as far as South Carolina. It feeds primarily on large insects such as dragonflies, grasshoppers, and crickets, or vegetation. It also takes small snakes, lizards and frogs and is able to fly and feed upon whatever prey it holds in its talons.

The swallow–tailed kite is especially well named, as it has a long, deeply forked tail similar to the barn swallow and it twists and turns like a swallow in flight, catching big insects.

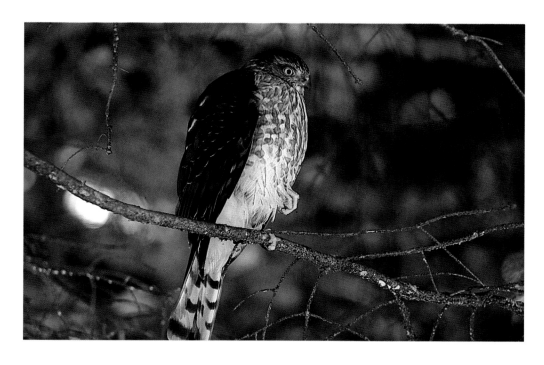

The sharp-shinned hawk, often called the "little blue darter," is the smallest of the three basic woods hawks. Its main food is small birds and it is often seen at or around people's bird feeders, seeking prey.

It is very difficult to tell a large female sharp-shinned hawk from a small male Cooper's hawk because they are the same size. However, the rounded tail feathers show that this bird is a male Cooper's hawk.

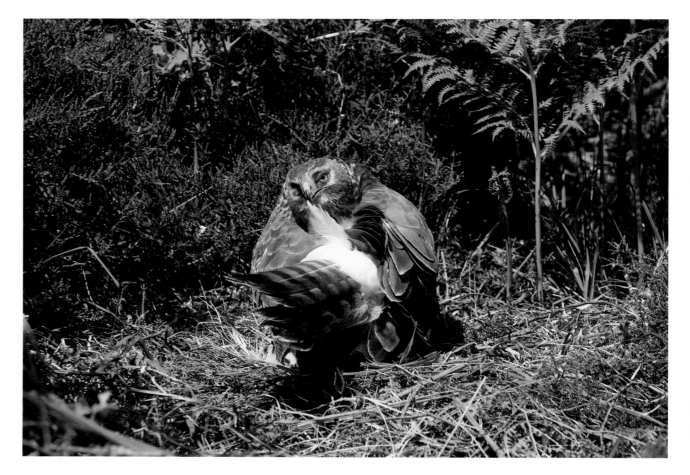

This hen harrier is busy preening its feathers. All healthy birds spend several hours a day preening, rearranging and often oiling their feathers before a storm.

The hen, or northern, harrier is one of the few hawks that builds its nest on the ground. It is usually on some slightly elevated spot in a marsh that is above the flood level. It is usually hidden by the tall grasses.

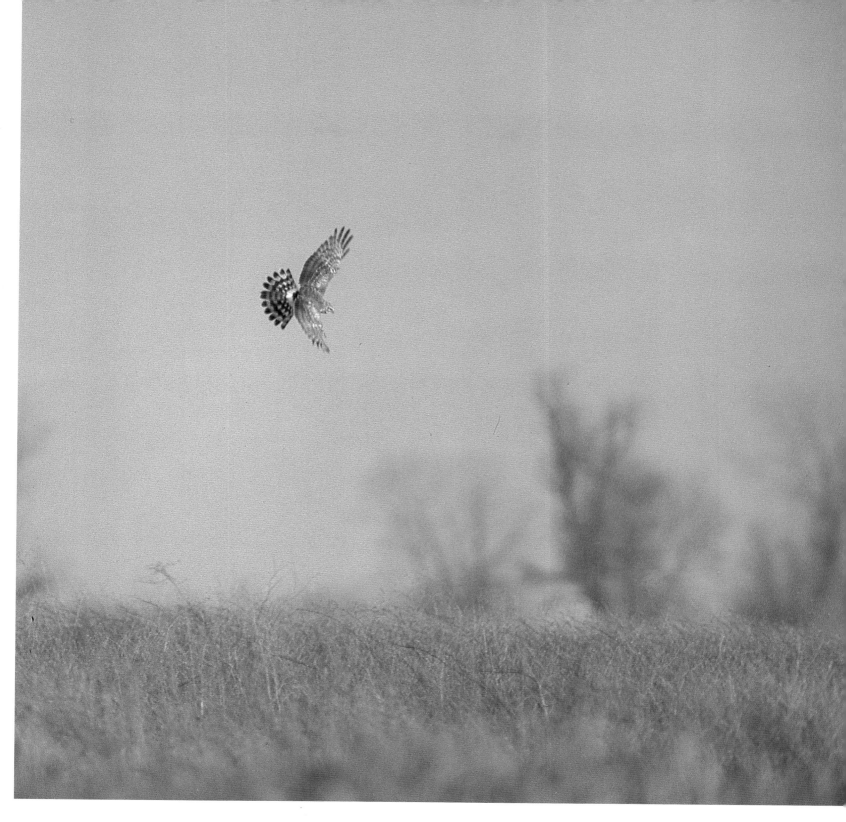

NORTHERN HARRIER

The sexes of the northern harrier *(Circus cyaneus)* are dimorphic, the smaller male being basically a grey bird while the larger female is brown. The most outstanding characteristic, besides the flight pattern, is its broad white rump patch. This white spot against the bird's contrasting plumage can be seen for a long distance. The birds have a wingspan of 42 inches (1 metre).

This harrier can be found in the temperate world completely around the world. Different subspecies are found in South America, Africa, and Australia. Prior to the first snowfall, or very shortly thereafter, the birds in the more northern reaches of their range migrate south to where the snow will not hamper their hunting.

The harriers are well known for their habit of coursing over field, plain, tundra, swamp, and prairie at a height of 10 to 30 feet (3 to 9.1 metres), on the average. They also have the ability to hover in one spot to get a better look at potential prey.

The harriers eat mainly mice, voles, ground squirrels, small birds, and small snakes.

The harriers of the world can be recognized by their low, sweeping flights over marshlands and grasslands and by the white saddle of feathers at the base of the tail.

Peregrines will use the same cliffside ledge as a nest site year after year. These young birds are being raised by their parents in the wild. In an effort to increase the depleted peregrine population, many of these birds have been raised in captivity and then released into the wild.

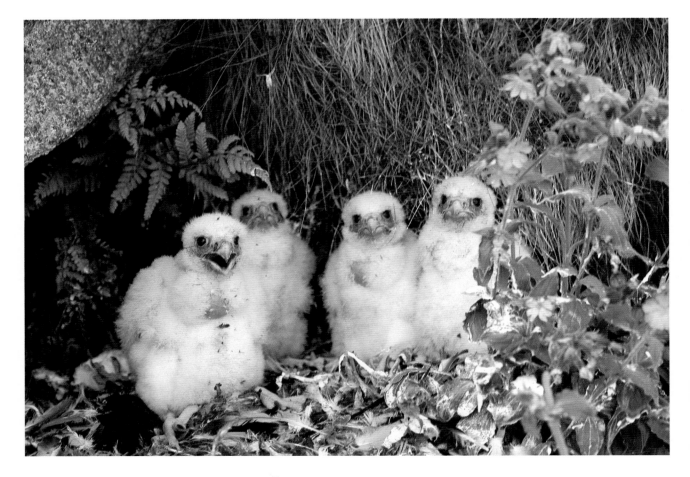

The peregrine falcon, sometimes called the duck hawk, is probably the fastest flying bird in the world. Peregrines in a steep dive after prey have been clocked at speeds up to 200 miles (320 kilometres) per hour.

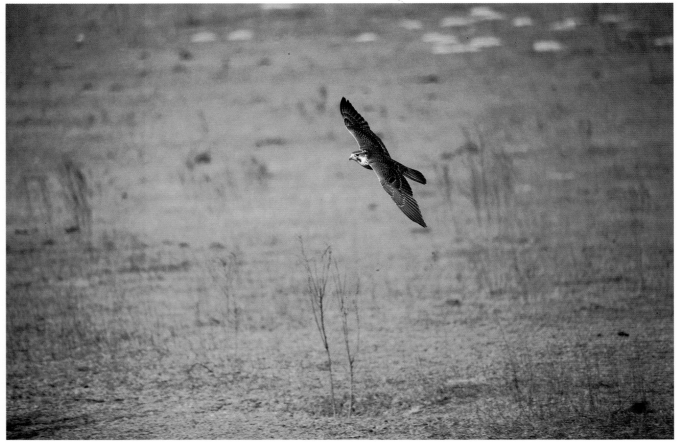

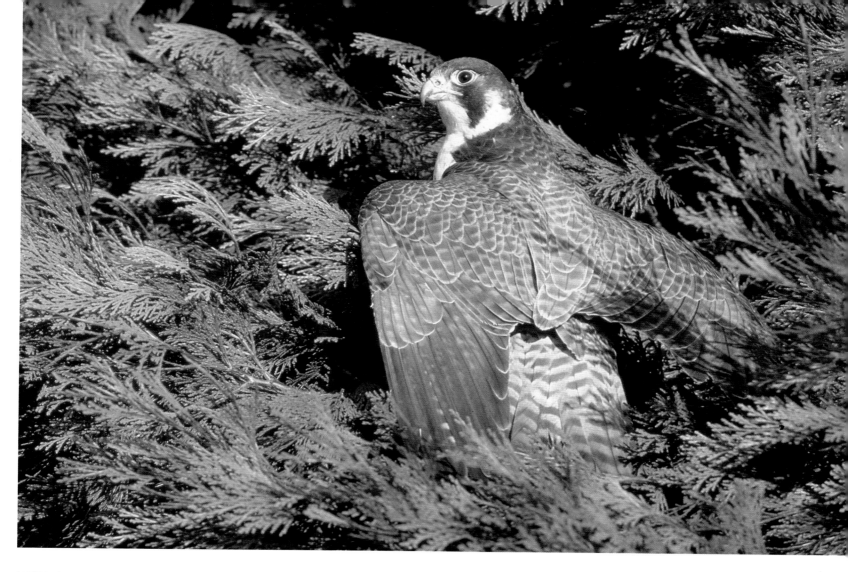

PEREGRINE FALCON

Because of its speed, grace, power, and endangered status, the peregrine *(Falco peregrinus)* is probably the best–known hawk in the world. The birds have a wingspan of 43 to 56 inches (1 to 1.4 metres). The heavily notched bill and the black moustachial line are the trademarks of this falcon. It also has long, tapered wings and a long, narrow tail. The head and upper parts are slate blue while its breast and belly are a buffy tan with dark brown bars and spots. The eye is dark and the feet are yellow.

The peregrine falcon and its subspecies are found throughout the world, except Antarctica, wherever there are rocky crags for them to nest on. Today the bird has taken to nesting on tall skyscrapers in the heart of the world's largest cities.

The peregrine is also called the duck hawk because it has always fed heavily on waterfowl. Today, with the explosion of the pigeon population throughout the world, the pigeon is becoming its mainstay, particularly in the large cities. Captive breeding programmes have brought the bird back from the brink of extinction to which it was pushed by the deadly poison DDT.

GYRFALCON

The gyr *(Falco rustigolus)* is the largest falcon in the world, attaining an overall length of 20 to 25 inches (50 to 63 centimetres) and having a wingspan of 48 to 54 inches (1.2 to 1.3 metres).

Because of its large size and speed, this is the most sought after species by falconers. This falcon has three colour phases. The most common is an all–white bird with black spotting and wing tips. There is also a basically all–brown bird with darker streaking and a grey phase with a light breast and belly heavily streaked with black.

This bird's range is the tundra regions around the world. Severe winters will force this falcon down into the temperate zone. At no time and in no area is it common.

The gyrfalcon feeds mostly upon birds and mainly upon the various types of ptarmigan. It also feeds upon ducks, gulls,

The peregrine is identified by its heavily notched beak, its black moustachial line, and its long, tapered wings and tail.

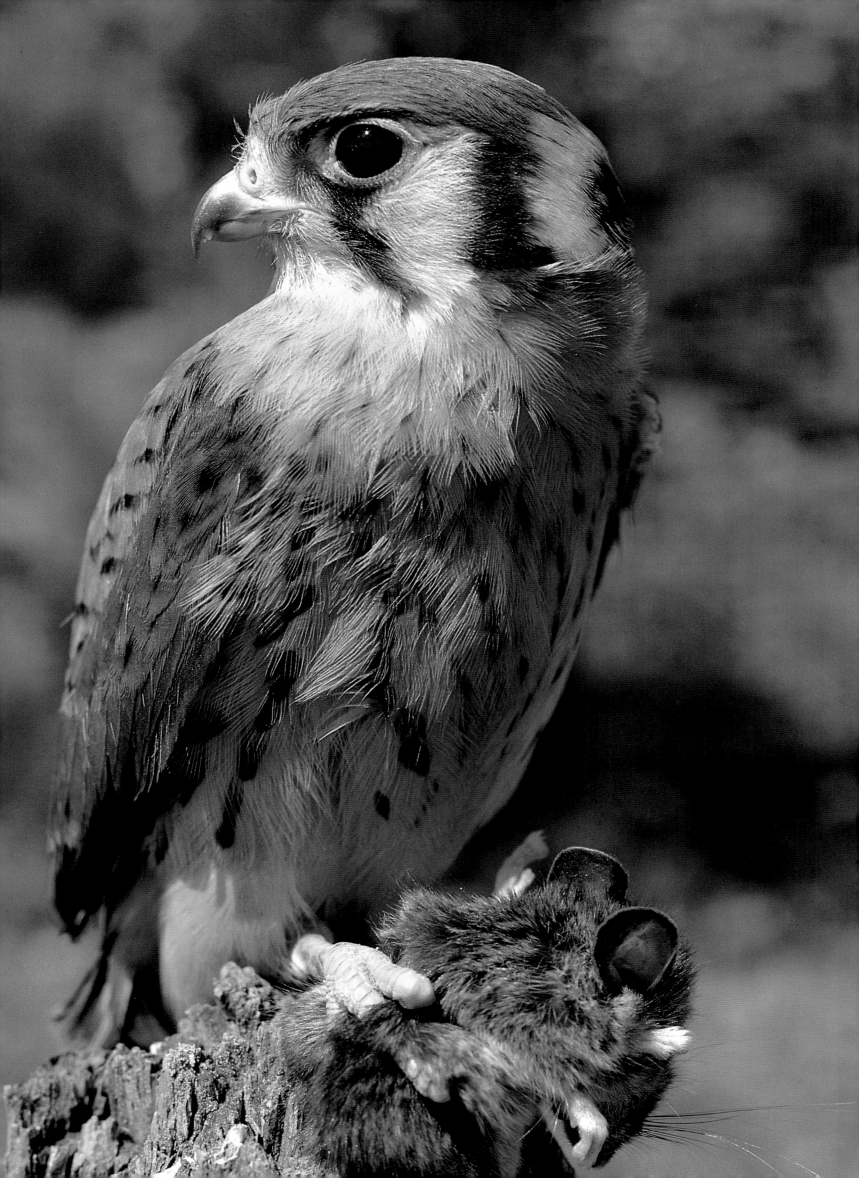

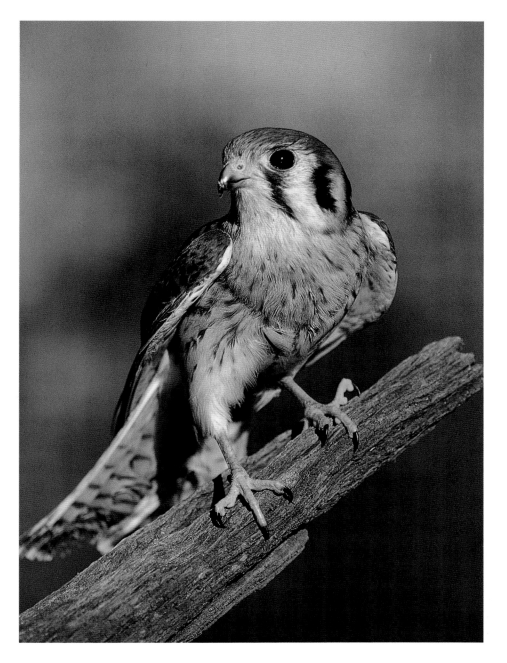

The North American sparrowhawk has recently been renamed the kestrel. These small falcons are very common all across North America and are increasing in population as they have adapted to nesting in man-made nest boxes in addition to the natural tree cavities.

shorebirds, geese, ground squirrels, voles, and lemmings. To hunt, it either sits on a cliffside or any elevated perch or flies in much the manner of a harrier.

AMERICAN KESTREL

This is a very common little falcon that is increasing in numbers because it has adapted well to man. The kestrel (*Falco sparverius*) has a wingspan of 20 to 24 inches (50 to 60 centimetres). Dimorphism is shown by the female having a basic rusty red on the back, tail, and wings while the male has slate blue wings. The female also has black crossbars on the top of its tail while the male does not.

This small falcon is found all over North America except in the tundra regions. Its range extends all the way down to the southern tip of South America. In North America it migrates out of the northern part of its range in the winter, which it spends in the northern tier of the United States.

Its main diet is grasshoppers, crickets, katydids, dragonflies, cicadas, and the like. It is most often seen sitting along the side of the road, perched on a telephone or electric wire scanning the ground below for its prey. This little falcon, more than any other hawk, often hovers in the air searching for prey.

Although this little kestrel is feeding upon a mouse, the bulk of this bird's diet, when available, consists of crickets and grasshoppers.

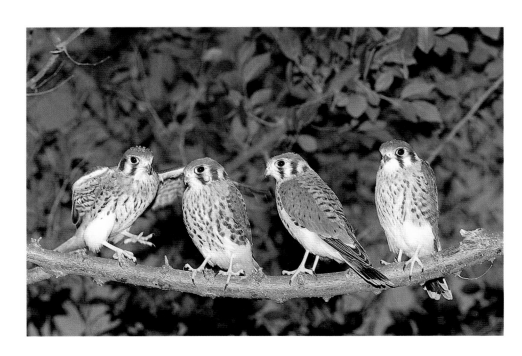

All of these young kestrels have the blue wing that identifies them as being males. The females have rusty red wings.

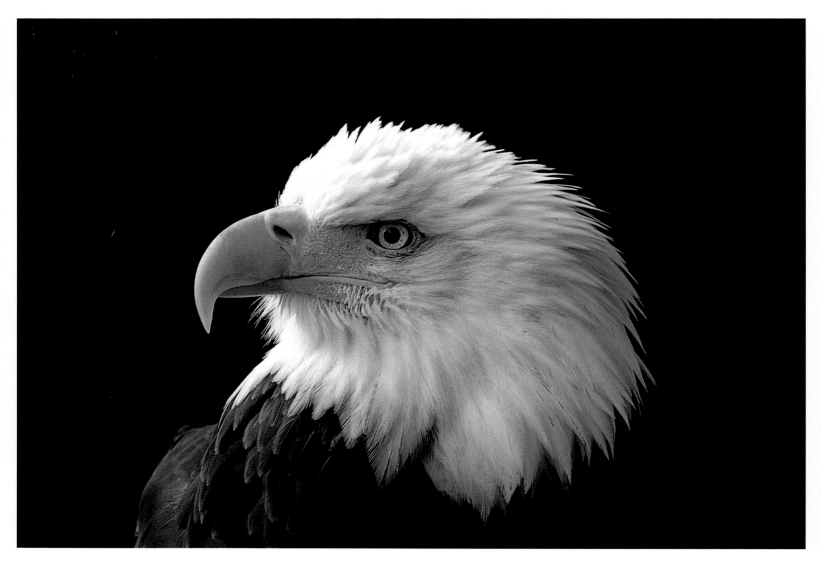

A classic portrait of an adult bald eagle. Its large sharply curved beak is designed to rend and tear flesh. The adults will tear a fish into little pieces to feed to young until they are large enough to tear it apart for themselves.

BALD EAGLE

The bald eagle *(Haliaeetus leucocephalus)* is perhaps best known as the national emblem of the United States. The bird has an overall length of 34 to 43 inches (86 to 109 centimetres) and a wingspan of 72 to 90 inches (1.8 to 2.2 metres). The adult bird is dark brown except for its snow–white head, neck, and tail feathers. The immature eagles are often confused with golden eagles because they do not begin to acquire their white plumage until their third year, and it takes two more years before it is completed. This eagle has bare tarsi, which are yellow, as are the eyes and beak.

Although this eagle is found all over North America, its numbers were greatly reduced by DDT poisoning. It is gradually recovering and reestablishing itself over much of its former range. It is still on the endangered species list. Some of the southern eagles migrate northward after their young have fledged. Many of the northern eagles migrate southward when the open water of lakes and rivers freezes up. They congregate in large numbers on rivers having late salmon runs or in areas where the water returned by power plants keeps the ice from freezing the rivers.

The bald eagle is primarily a fish eagle, being found along the coastal regions and on inland lakes and rivers. It feeds primarily on fish, although it also preys upon ducks.

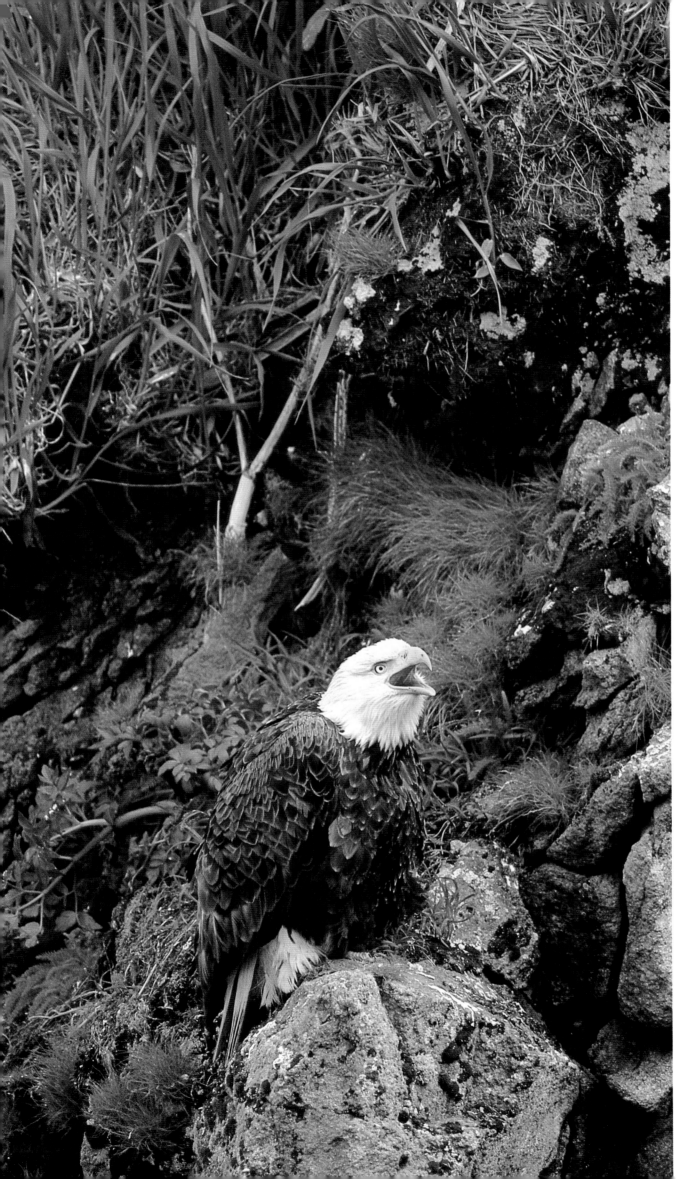

The piercing scream of an eagle can be heard for a long distance. A mated pair of eagles call frequently to stay in touch with one another.

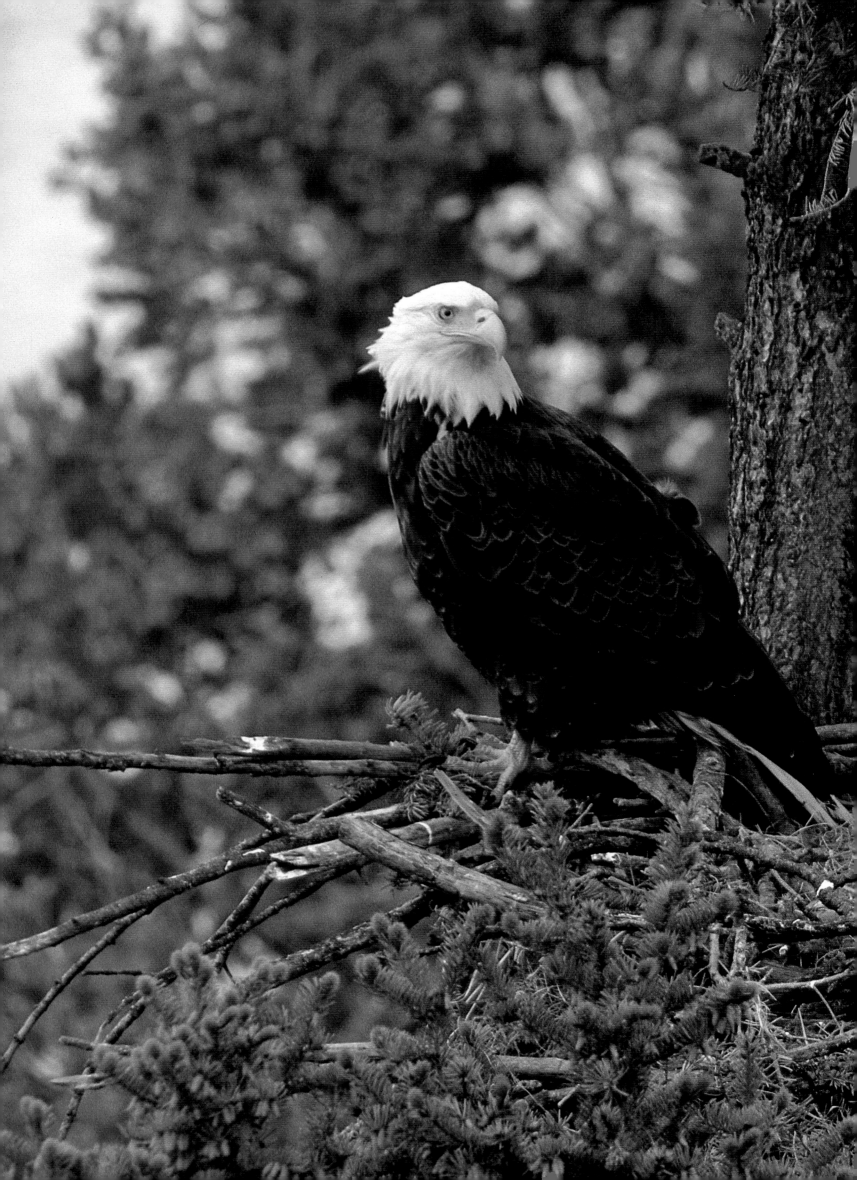

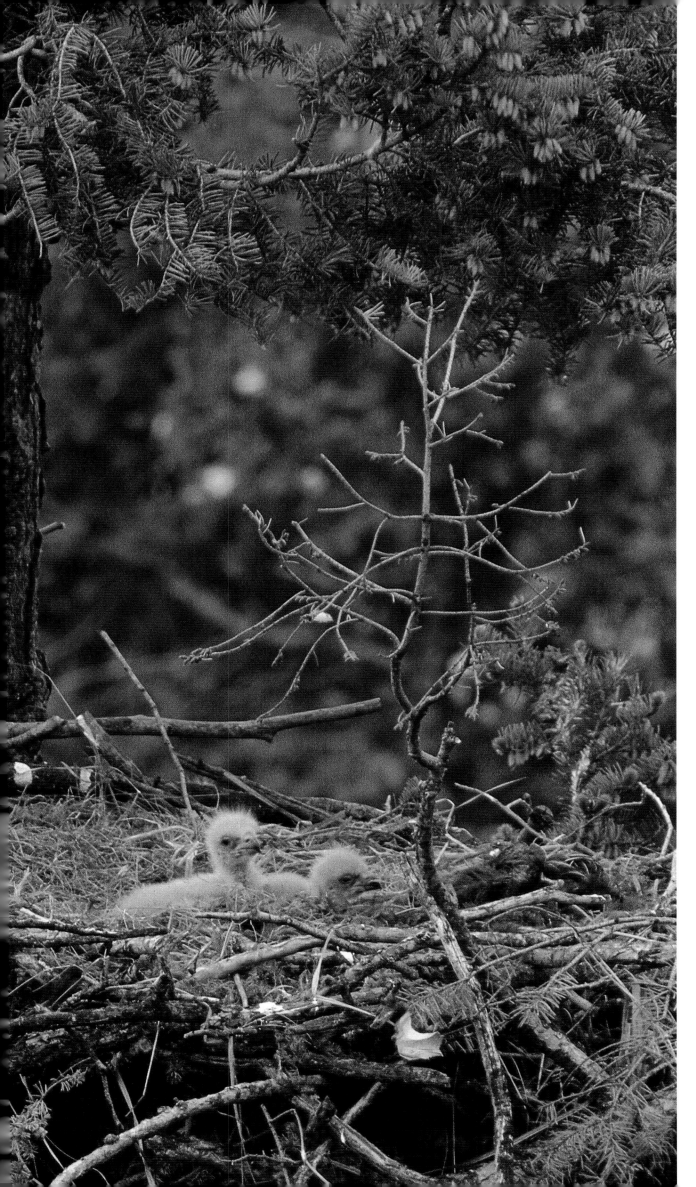

The nest of the
bald eagle is a
large, bulky affair
that is added to
each year and
is used year after
year. Both of the
adults care for
the eaglets,
shown here.

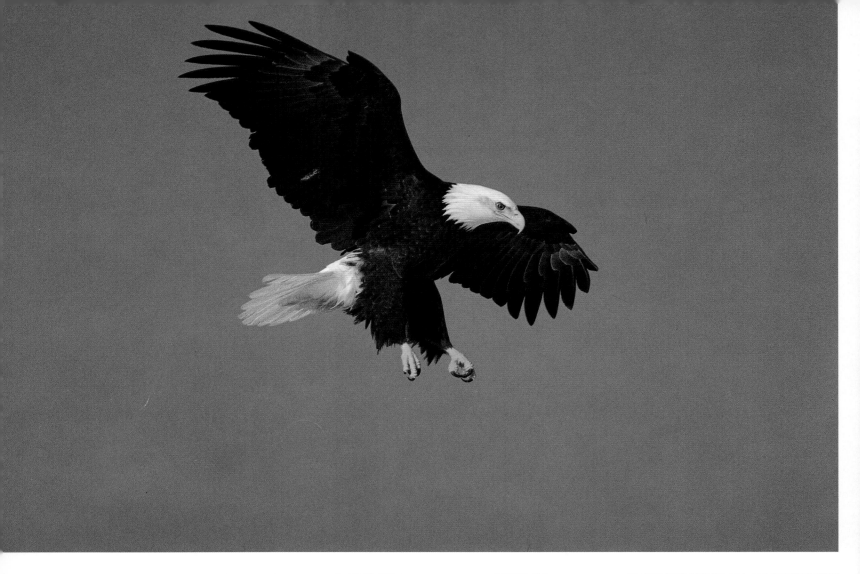

With its wings cupped, its tail fanned, and its feet extended, this bald eagle is braking its air speed prior to landing.

Bald eagles concentrate in winter in areas of open water, or where there are late salmon runs.

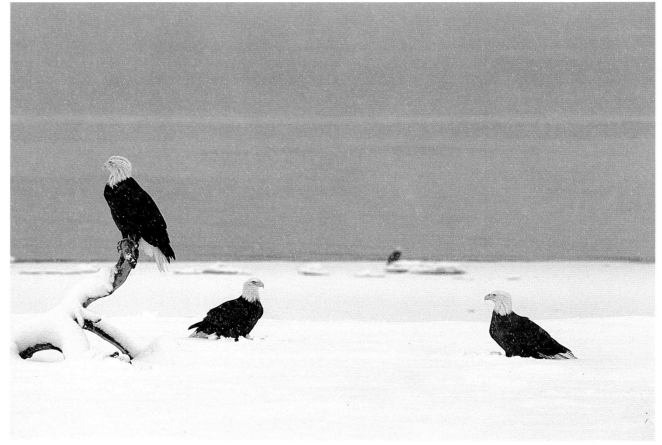

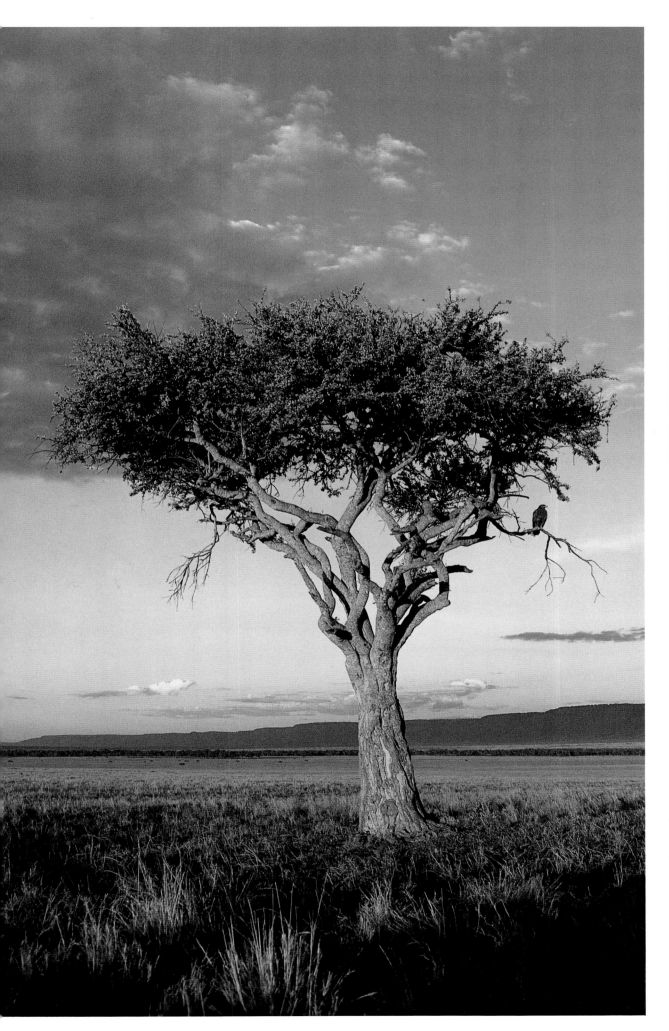

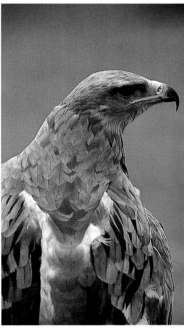

The tawny eagle is well named because its basic colouration is a tawny tan. The bird's subspecies vary in colour in different parts of the world.

In the high plains region of east Africa, most of the trees are some type of acacia. The tawny eagles perch in the trees while hunting for game, and they often build their nests high in their boughs.

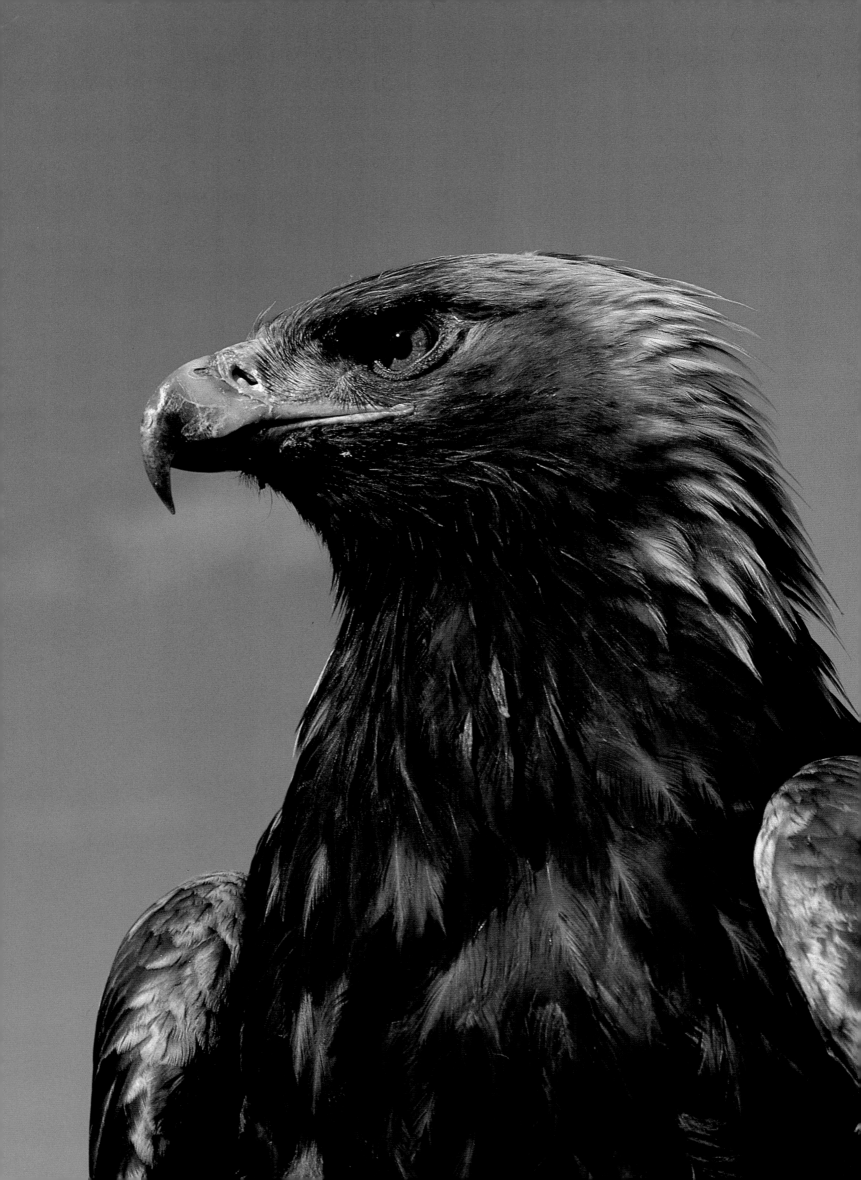

GOLDEN EAGLE

Although the golden eagle *(Aquila chrysaetos)* is basically a dark brown bird, it does have lighter, golden feathers on its head and its neck. The birds have a wingspan of 78 to 90 inches (1.9 to 2.2 metres). A good identifying characteristic is the eagle's feathered tarsi. Its eyes are also dark brown, while its beak and feet are bright yellow.

Although this bird lives primarily in the western states from Alaska to Texas, it is not a rarity on the North American East Coast.

The birds are often seen migrating down the eastern mountains' hawk routes and are forced south when most of their prey species are hidden by deep snow.

The golden eagle is more of a mammal hunter than is the bald eagle. It sometimes eats carrion, but most of its prey consists of animals it has killed itself. Its main foods are rabbits, hares, marmots, ground squirrels, snakes, and the young of such animals as antelope, deer, and sheep.

Most of the nests of golden eagles are on cliffside ledges. Occasionally the eagle will build a nest in a tree, usually a conifer. This eaglet is about three weeks old.

Notice the bony protrusion over the eyes of eagles, which acts as a shade to protect their eyes from sun.

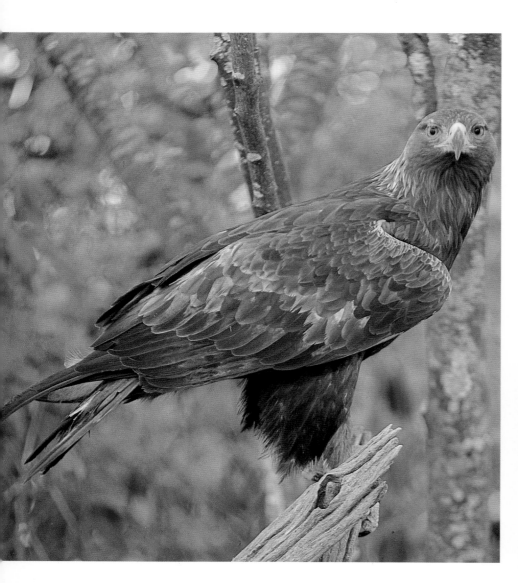

The golden eagle likes to sit on dead snags, where it will have an unobstructed view of the area in which it is hunting.

Primarily a bird of the western half of the North American continent, the golden eagle is ordinarily a bird of the wide open spaces. It often hunts above the tree line in the western mountains and thus must use a rock for its perch.

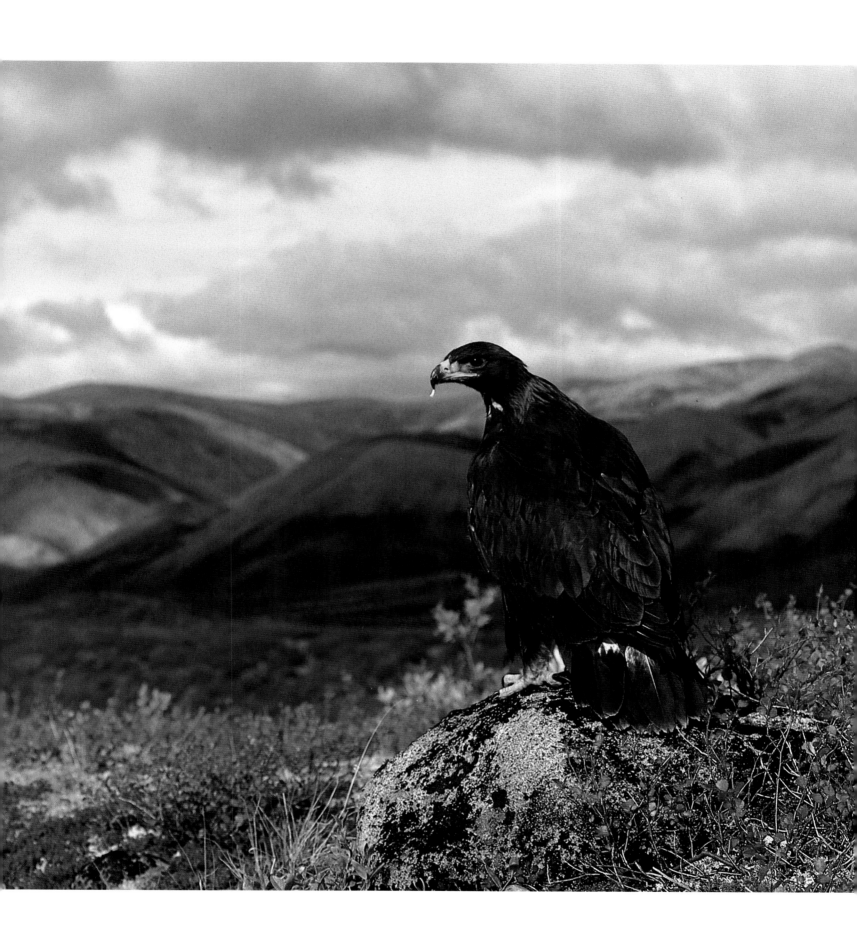

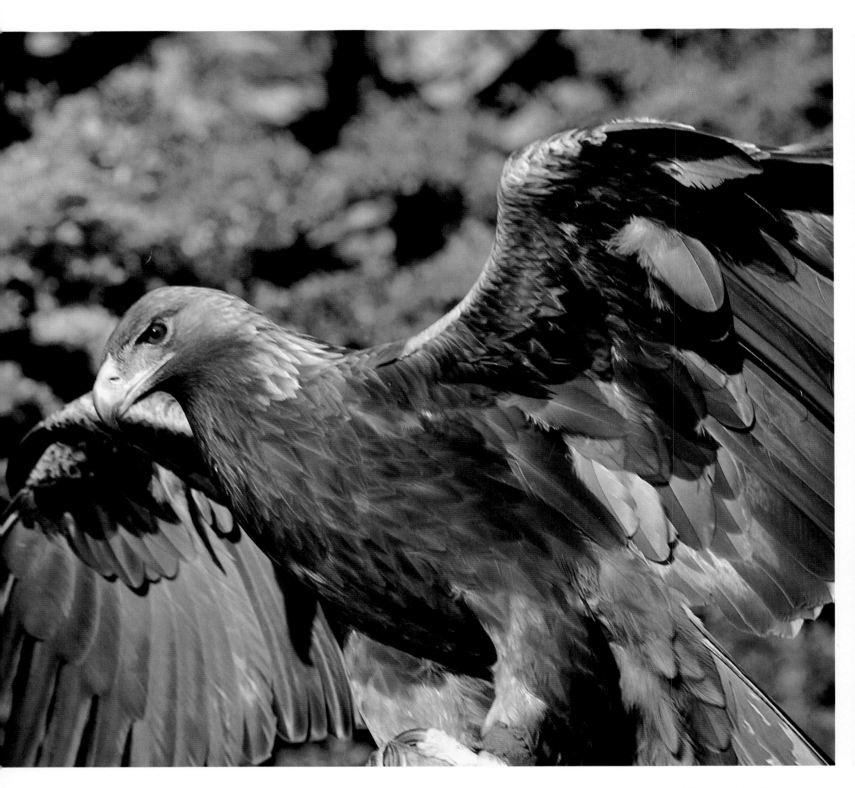

The head feathers of these eagles have a golden tint to them, which has given these birds their common name.

The golden eagle finds its prey by soaring high in the sky
or by sitting on a perch, and then flying off to capture it:
The golden eagle is a very aggressive bird, often attacking
animals and birds that weigh much more than it does.

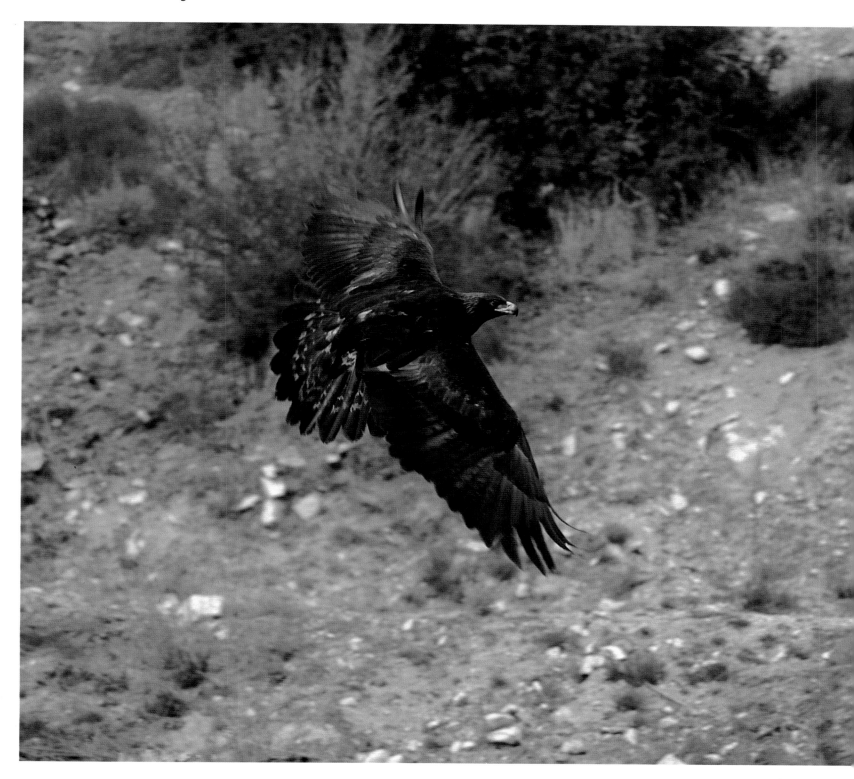

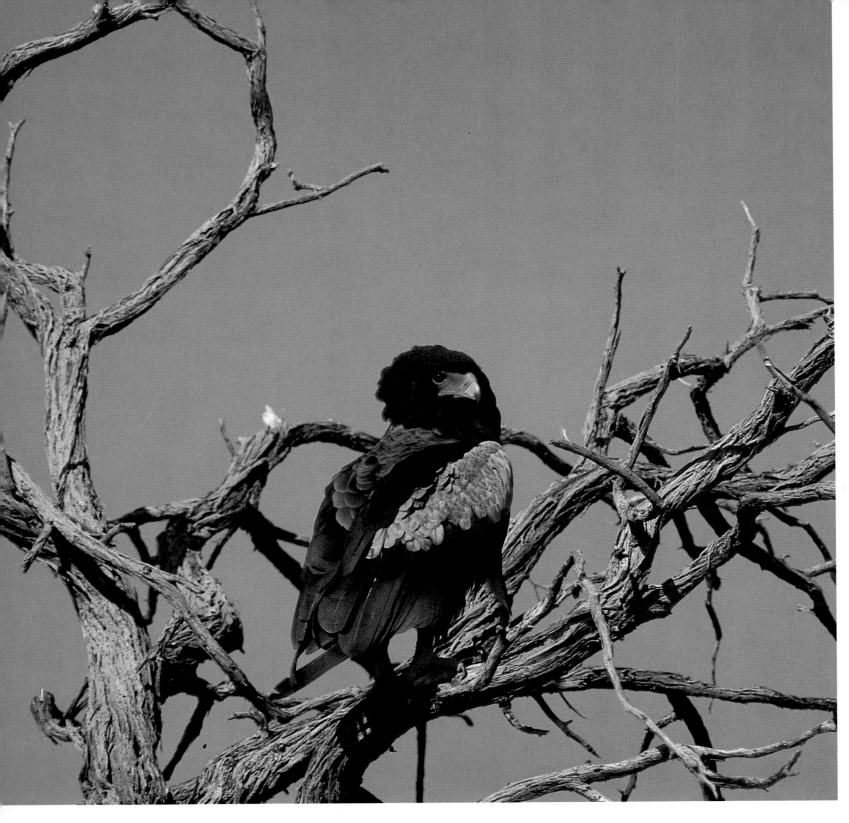

BATELEUR EAGLE

The bateleur *(Terathopius ecaudatus)* is a very pretty bird, with its basic dark plumage and bright red face and feet. It has rusty brown feathers on its back and tail. It has large white patches on the under and upper surfaces of its wing. It is exceedingly easy to identify in flight because it appears almost tail-less, as the tail feathers are short. The young resemble tawny eagles before they acquire the red facial colouration. They have a 69–inch (1.7–metre) wingspan.

They are found throughout all of Africa south of the Sahara Desert range in regions of open plains, thornbush, and savannahs. The bateleur eagle is classified as a snake eagle and it does feed upon even the most poisonous ones. Its main food is carrion, and it will pirate food from other birds that have made a kill. It will also force vultures to disgorge food they have eaten.

MARTIAL EAGLE

The martial eagle *(Polemaetus belligosus)* is the largest eagle in Africa, measuring up to 44 inches (1.1 metres) in total length, having a wingspan up to 96 inches (2.4 metres). It is a handsome bird with a dark brown head, breast, back, tail, and upper wing surface. The lower breast, belly, legs, and undertail surface of this crested eagle are pure white with scattered black dots.

It is found across the lower half of the African continent in areas of open plains and savannahs. Its seasonal movements are prompted by the availability of food.

Africa's largest eagle, the martial eagle is a large, heavy, very powerful, aggressive bird that doesn't hesitate to attack animals as large as antelope.

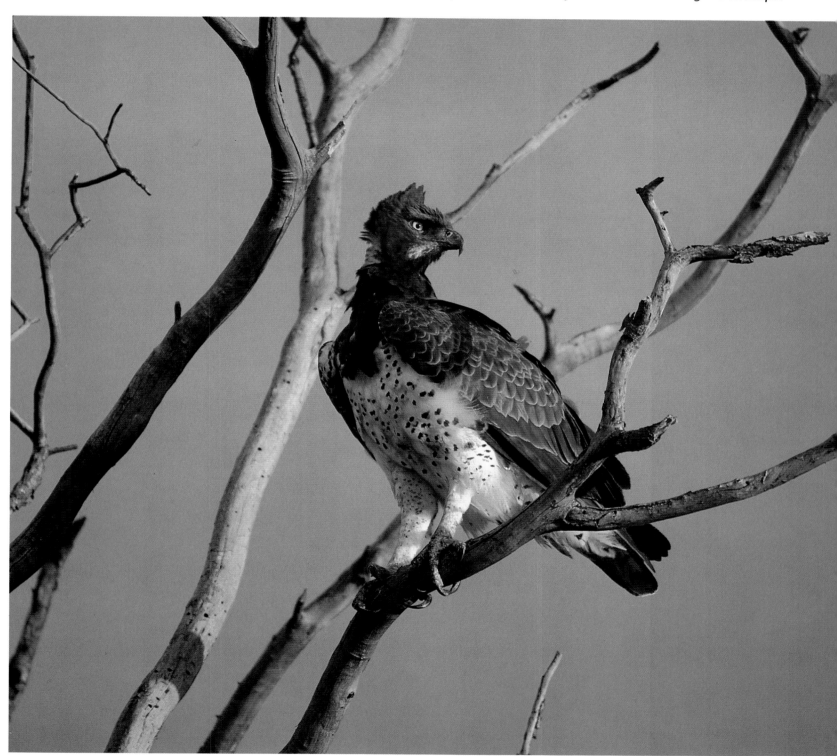

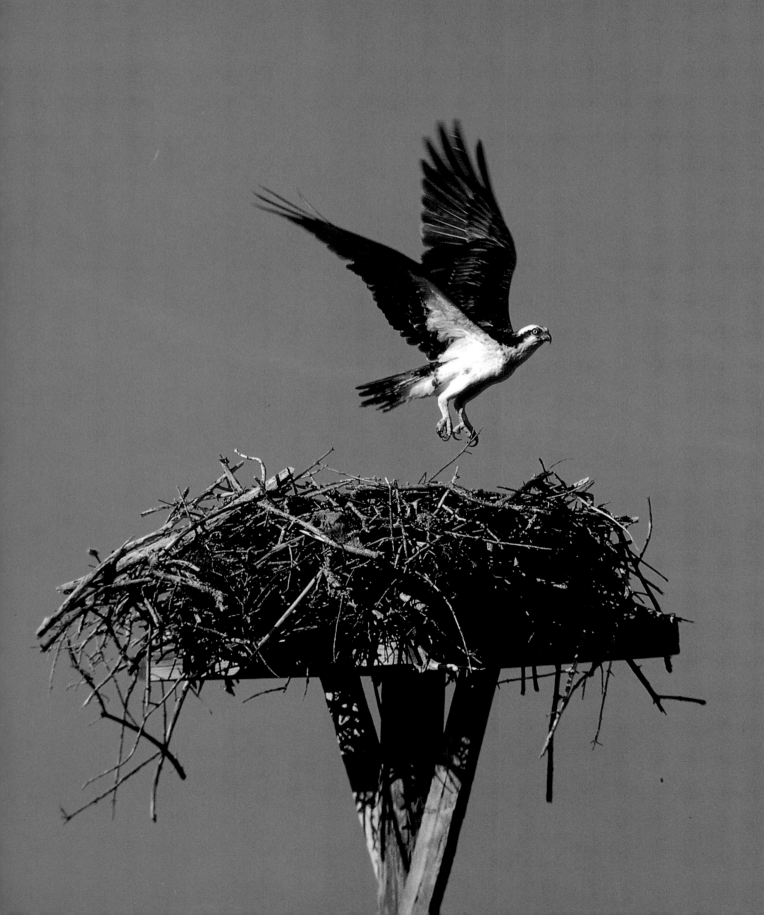

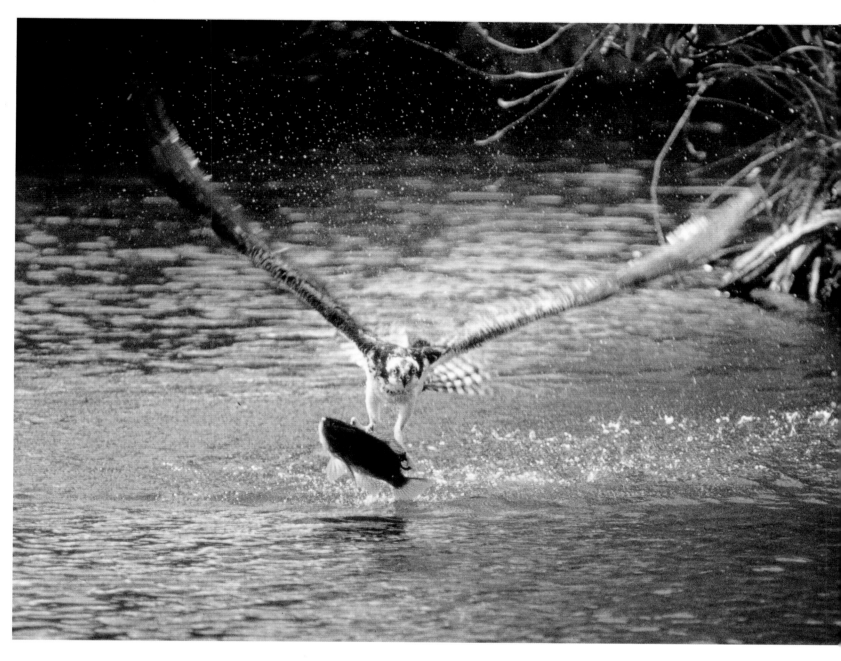

The martial eagle spends most of its time soaring, sometimes at great heights. Although it is large enough to kill small antelope, and it does, its main food consists of the many game birds with which Africa abounds.

OSPREY

The osprey *(Pandion haliaetus)* is almost eagle-sized, having a wingspan up to 72 inches (1.8 metres). It has a white crown, throat, breast, belly, and legs. Its underwings and tail are white, barred with black; the top of the wing is dark. In flight, its wings are

This osprey has just swooped down and snatched a large fish out of the water. From time to time, an osprey catches a fish too big to carry and drowns when it cannot remove its talons from its intended meal.

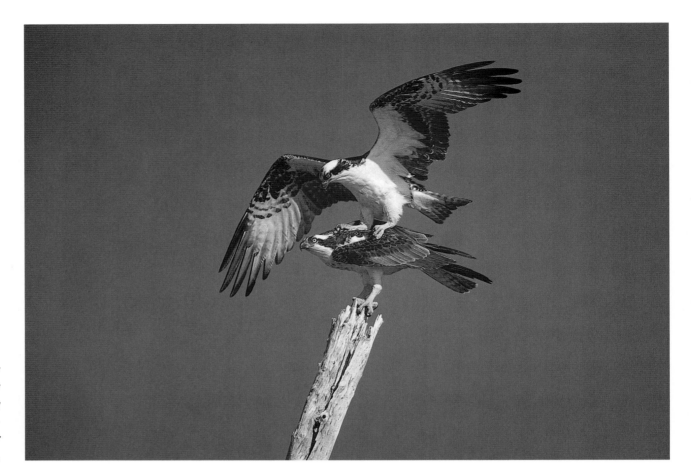

Osprey display the copulatory position. The male is considerably smaller than the female.

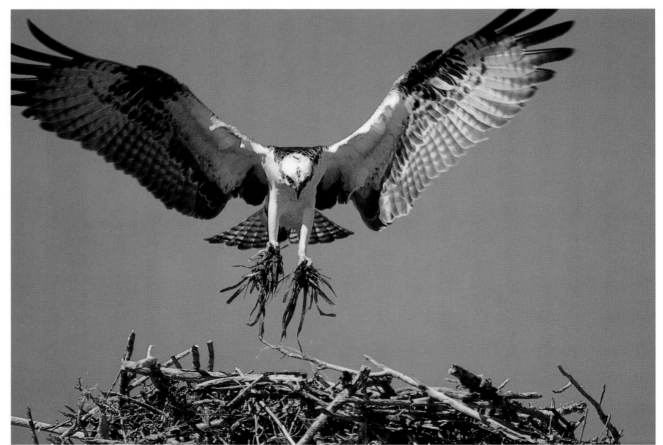

This osprey has brought aquatic vegetation to be used in the bowl of its nest. This soft lining is added just before the actual egg laying takes place.

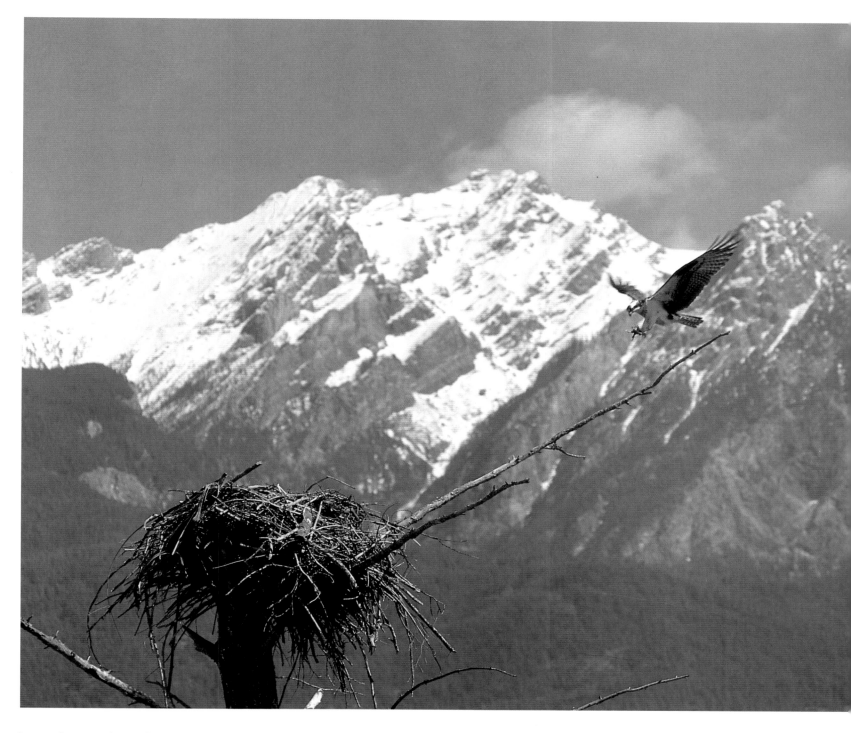

bent forward at the wrist like a shallow capital M and the primary feathers are widely separated or slotted. The eyes are bright yellow, and the beak is black.

The osprey, or fish hawk, is one of the most common hawks in the world, being found on every continent except Antarctica. It is found wherever there is open water that can be fished. Its migration is forced by the freezing up of the freshwater rivers, lakes, and ponds.

The osprey feeds almost exclusively on fish, which it catches by plunging into the water. It often fishes from a perch, but more often soars over the water. Spotting a fish, the osprey may hover until the fish gets closer to the surface. If the fish is very close to the surface, the osprey may be able to snatch it while stooping down. If the fish is more than a foot below the surface, the osprey plunges in after its prey.

Situated atop a dead tree beside a lake in the Canadian Rockies, this osprey nest will be used continuously over a period of many years. The bird adds new material each year.

This great grey owl is bringing a large meadow vole in to feed her young. The owl's nest is located on the tall stump of a dead tree. The owlets are about one month old.

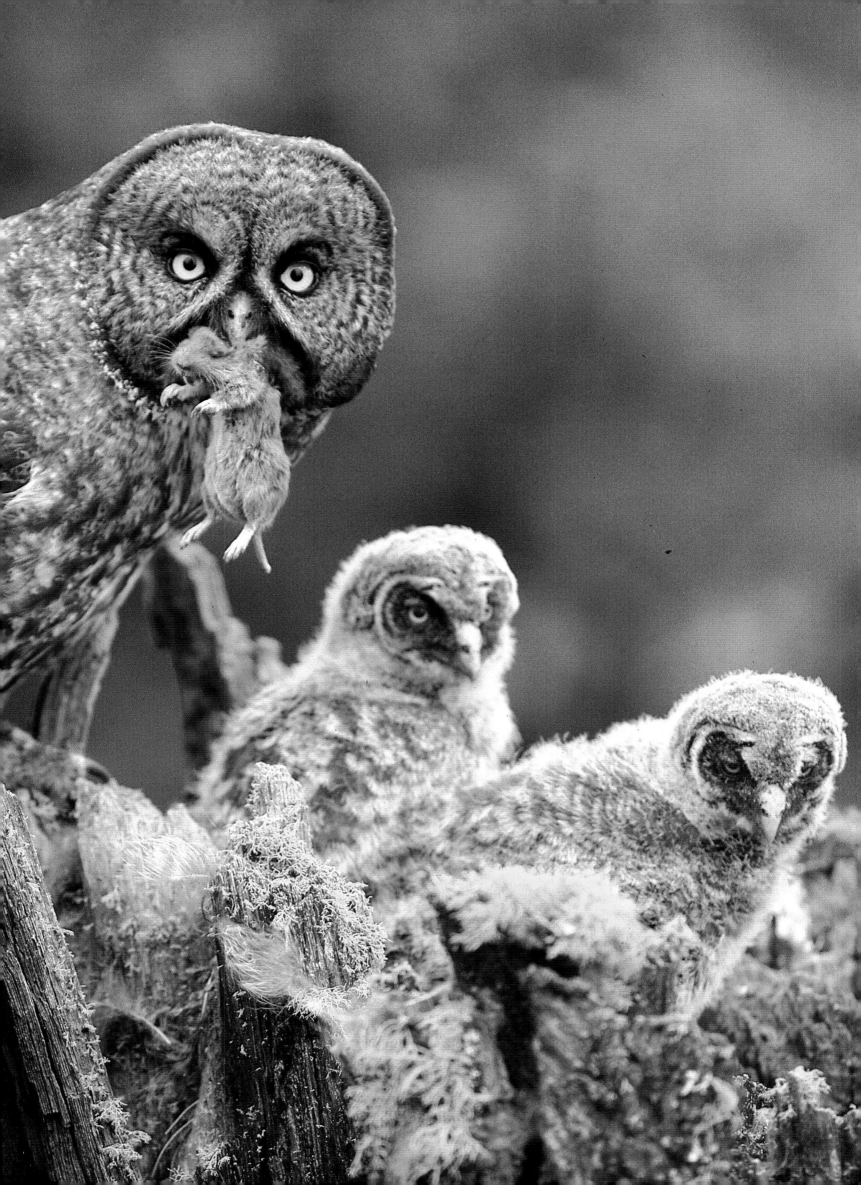

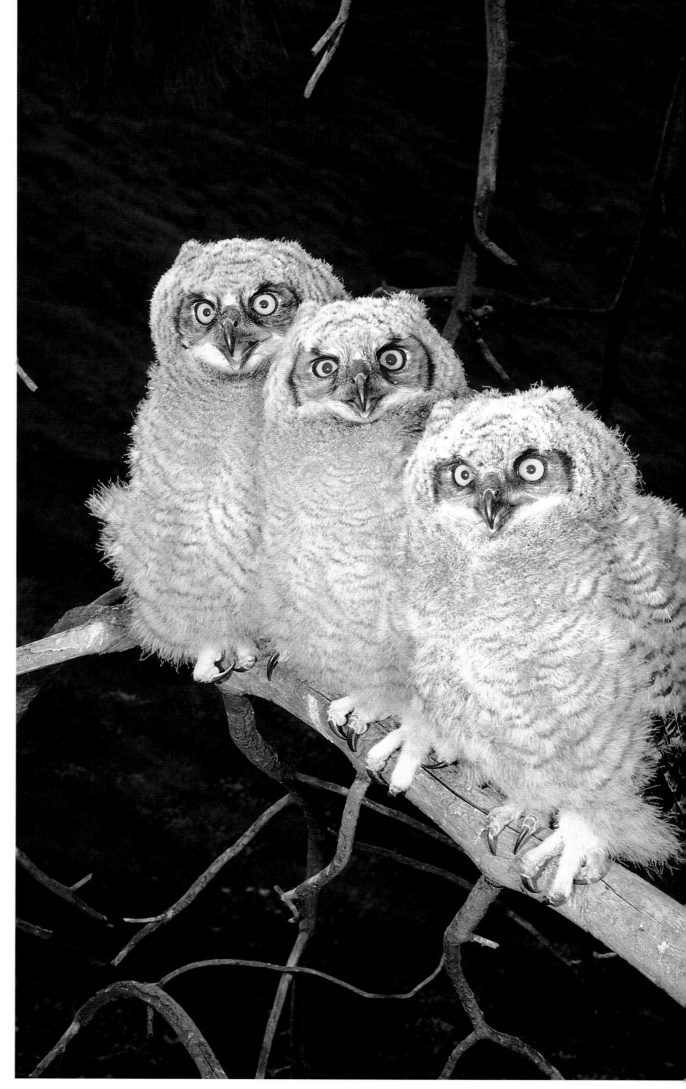

These young great horned owls are almost old enough to leave the nest on their own. Great horned owls are very protective of their young, often attacking human intruders.

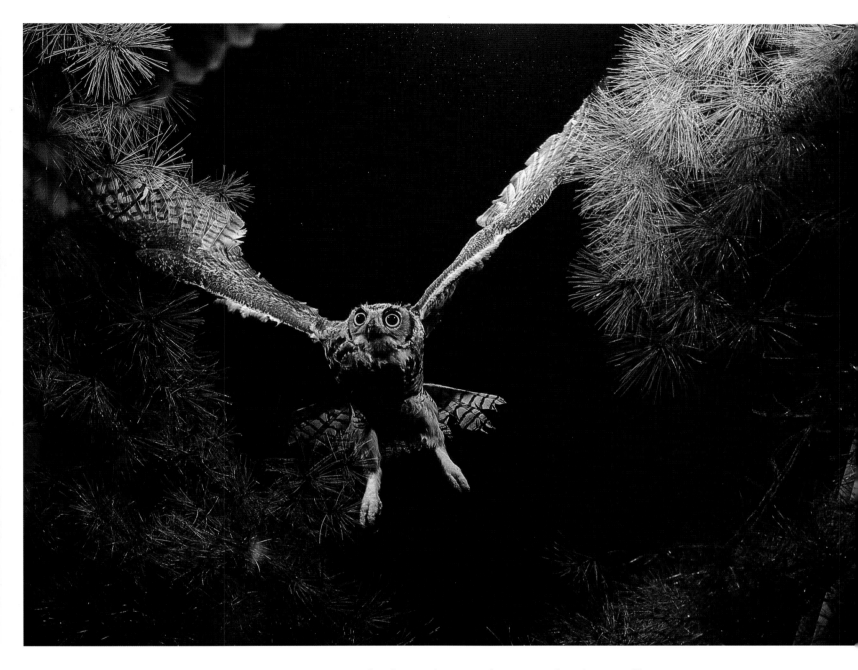

GREAT HORNED OWL

This is the largest 'tufted' owl in North America. It has two prominent feathered tufts, giving it the name 'great horned'. The great horned owl *(Bubo virginianus)* is a large, powerful creature, having a wingspan up to 60 inches (1.5 metres).

The owl can display several basic shades of tan and grey. It has white feathering at the throat and black barring on its breast and belly. It has slightly darker mottling on its back. The brown facial disk surrounds bright yellow eyes.

The great horned owl is highly adaptable and is found in forests, jungles, swamps, deserts, lower mountainsides, and city parks from the tree limit in the Arctic all the way down to the southernmost tip of South America. The great horned owl usually spends the day roosting close to the trunk of some dense evergreen tree, where it hopes to escape discovery by the crows. As it often feeds on crows at night, the crows 'mob' and harass the owl during the daylight hours, hoping to drive it from their area. It is a ferocious bird, sometimes called the 'tiger' of the air. The great horned owl feeds upon all types of rodents, rabbits, hares, muskrats, opossums, weasels, mink, game birds, waterfowl, large song birds, shorebirds, skunks, and porcupines.

As with all owls, the edges of the great horned owl's wing feathers are soft. This enables them to act as silencers, allowing the bird to fly noiselessly while hunting, not alerting its potential prey.

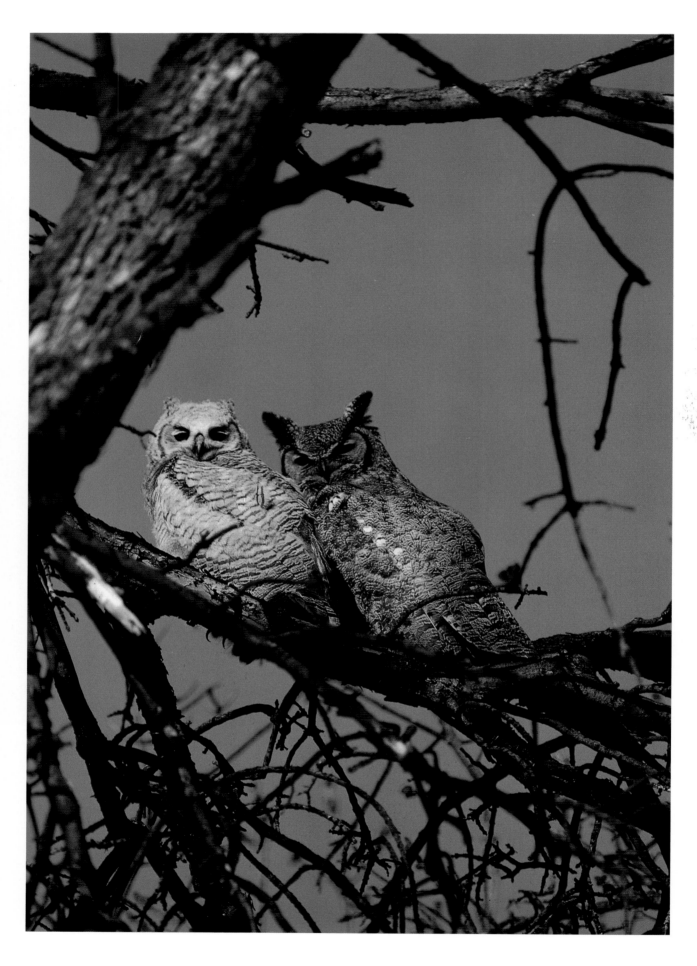

Even after the young great horned owls leave the nest, the parents stay close to them and will continue to provide their food for several more months.

This great horned owl has caught a white-footed mouse. The owl swallows small prey whole and then regurgitates a pellet containing all of the indigestible pieces of bone and fur.

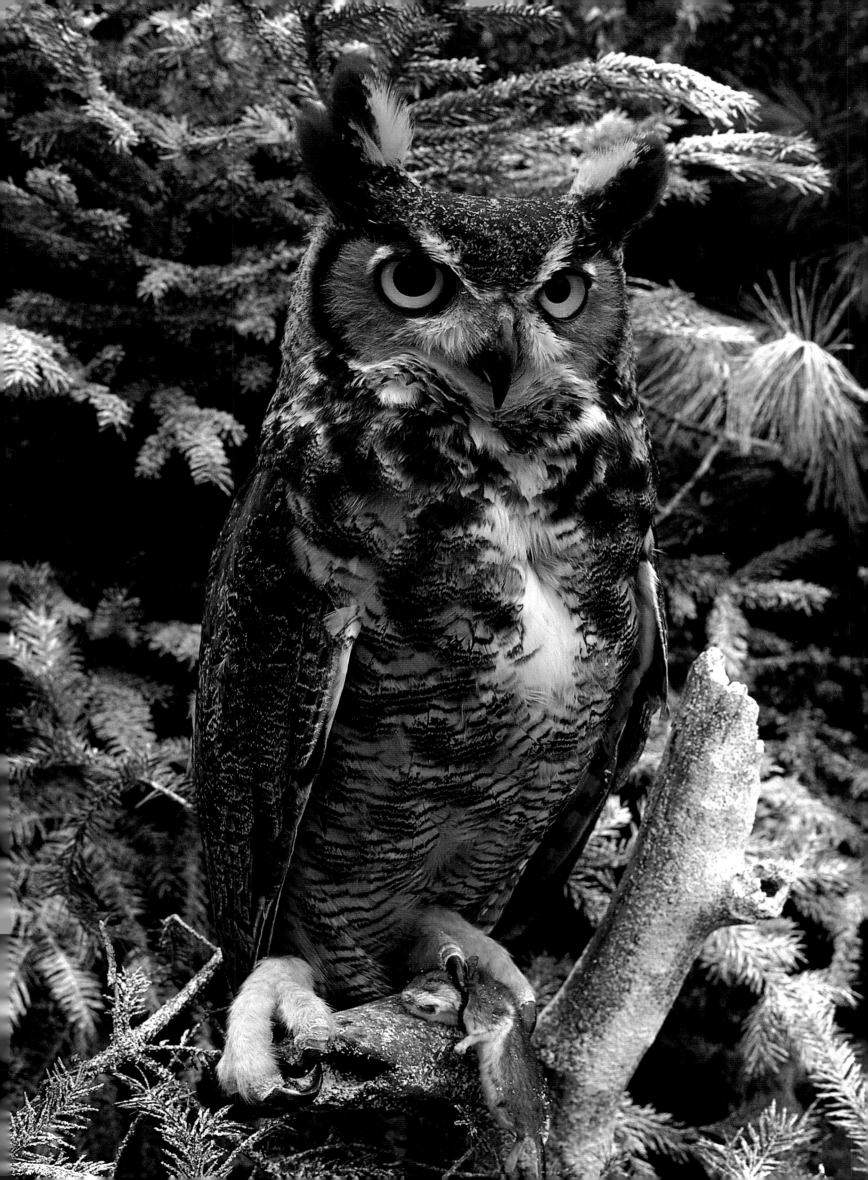

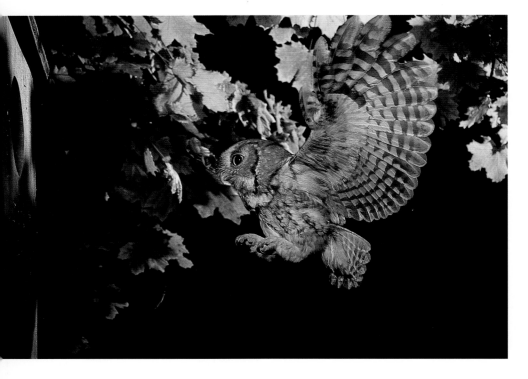

SCREECH OWL

The screech owl *(Otus asio)* is probably the most common owl in North America. It is dimorphic; in the east it is a grey, brown, or bright rusty colour; west of the Rocky Mountains, the owl is usually just found in a dark grey phase. These owls have a wingspan of 18 to 24 inches (45 to 60 centimetres). The bird has tufts that look like upright eyebrows. Its yellow and black eyes peer out from a facial disk.

They are found all across the United States and up the Pacific Coast to Alaska. The name screech owl is a misnomer, and this little owl is called the 'shivering owl' in the southern part of the United States. Its frequently heard, tremulous call is softly whistled, starting on a high note and sliding down the scale. It feeds upon any rodent that it can overpower, up to the size of small rats.

Screech owls are cavity–nesting birds. This red–phase screech owl is flying into its nest in a man-made wood duck nest box. It is this owl's ability to adapt that has allowed it to maintain its numbers despite man's cutting down most of the hollow trees.

Screech owls are considered to have just two distinct colour phases, red and grey. However, in the red stage, there is a tremendous gradation, ranging from a light sandy tan to a deep rusty red.

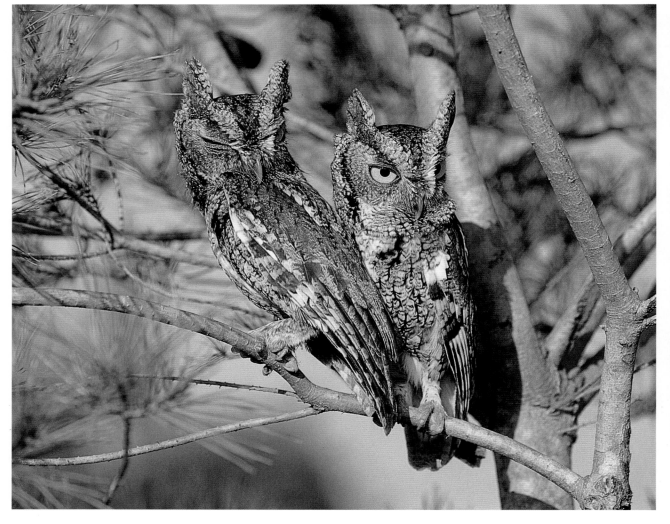

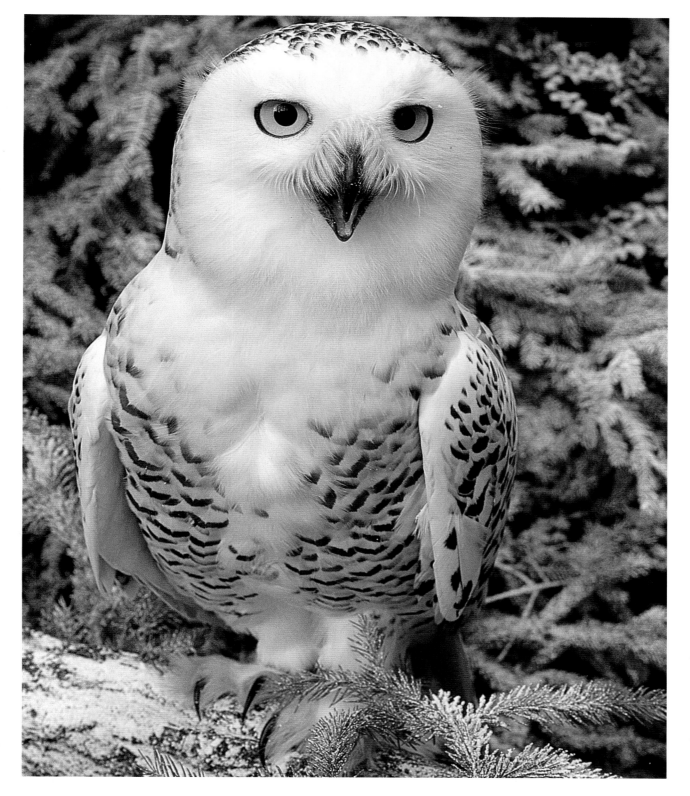

Following page:

These young snowy, or arctic, owls have left their nest and are hiding in the midst of a carpet of wildflowers on the Alaskan tundra.

This female snowy owl has heavy black barring on her basic white plumage, while the male does not. Lacking ear tufts, she has a rounded head. To help withstand the cold of the Arctic, even her toes are feathered.

SNOWY OWL

The snowy owl *(Nyctea scandiaca)* is one of the largest and most powerful owls in North America. It measures up to 27 inches (68.6 centimetres) in total length and has a wingspan of up to 66 inches (1.6 metres). It has no ear tufts. The rounded head has large facial disks featuring the large yellow, dark–centred eyes. Its basic colouration is snow white with dark barring, which varies greatly among individuals. The almost pure–white birds are the males; the females are more heavily barred. Its tarsi and toes are heavily feathered, and its bill is also almost hidden by feathers.

The snowy owl is often referred to as the arctic owl because it is found in the polar regions all around the world. It usually does not migrate, but is forced to do so every fourth year when the lemming cycle is low. The birds often come down as far as the Middle Atlantic states.

The snowy owl usually perches on the ground, on grass tussocks, driftwood, and the like, because there are no trees in its natural haunts. When it comes south, it frequently sits on barns, haystacks, utility poles, and fence posts. It is very alert, hunting by daylight as well as in the dark. Because of its size and power, it can take snowshoe hares, rabbits, and such furbearers as weasels and mink. It also eats small birds, mice, and lemmings.

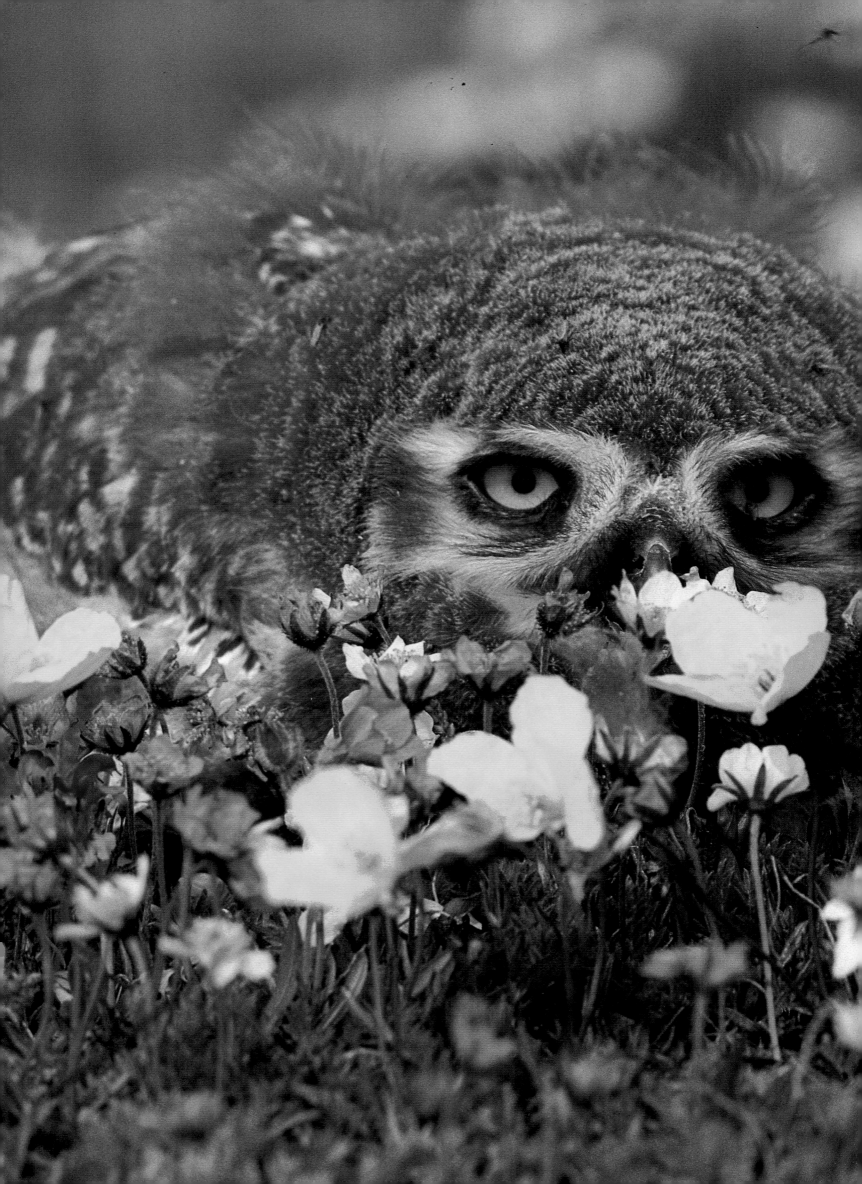

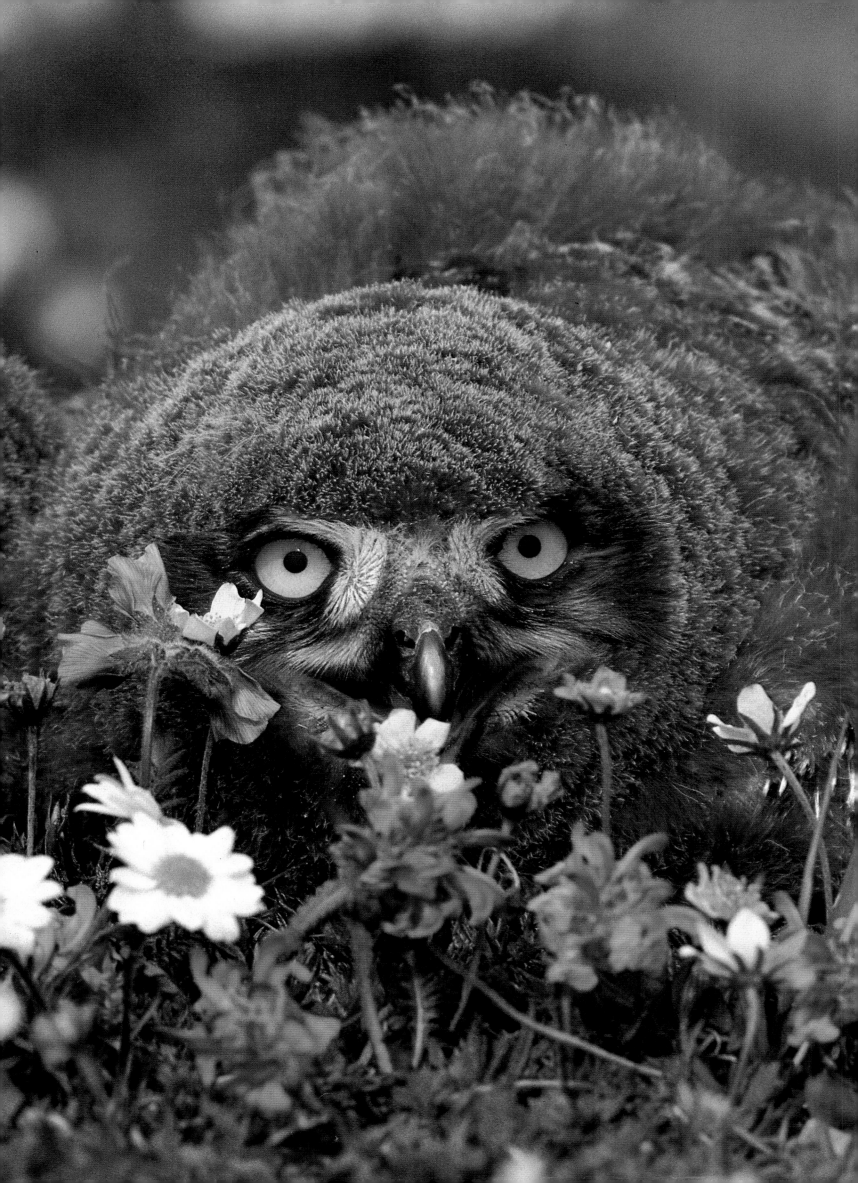

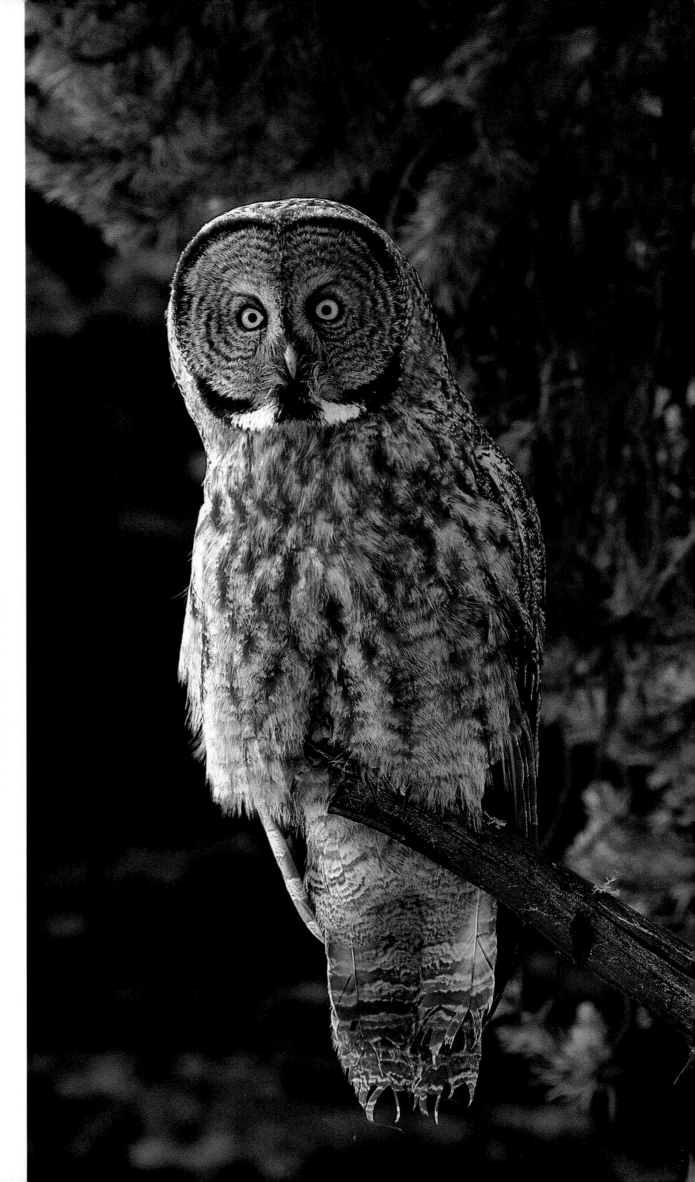

The great grey owl is the largest owl in North America in overall size, but it is not the heaviest. The concentric dark rings in this owl's facial disk are very prominent, unlike the barred owl's rings, which are faint.

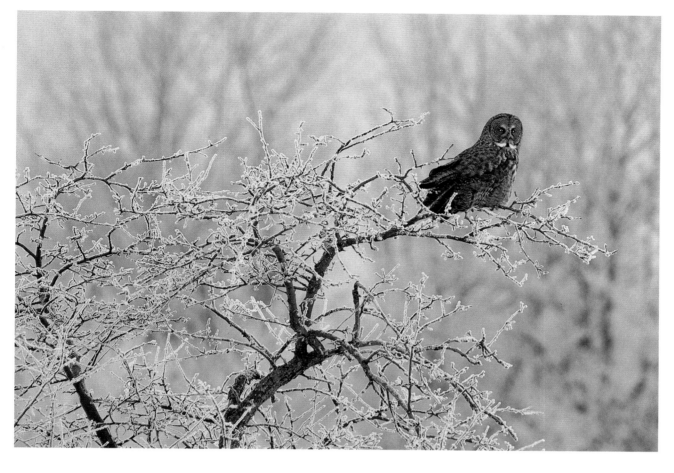

Great grey owls hunt in whatever grassy openings are found in wooded areas. Such areas usually abound in voles and mice. The birds are quite conspicuous because they sit on the open trees or snags overlooking the meadows.

GREAT GREY OWL

The great grey owl *(Strix nebulosa)* is the largest owl in size, measuring up to 33 inches (83 centimetres) in total length. It has a wingspan of up to 60 inches (1.5 metres).

This owl is a basic dark grey in colouration with heavy black barring. It has a rounded head and no ear tufts. Its facial disk of feathers has concentric circles around the small yellow eyes.

The range of the great grey owl extends around the world in the taiga and northern forests of the north temperate zone. It migrates southward only when forced to do so by a shortage of food.

This bird is generally conceded to be quite fearless, but its boldness is more apt to be caused by its lack of contact with man. It hunts at any time of the day or night. When sitting up against the trunk of a large evergreen tree, it becomes quite inconspicuous. However, it frequently sits on a dead snag in the open, overlooking grassy meadows, where it hunts for mice and voles. The great grey feeds upon hares, rabbits, grouse, squirrels, and small birds.

Because it may hunt at any time in a twenty-four–hour period, the great grey owl can sometimes be seen flying about in the daytime. Being primarily a bird of the northern forested areas, this owl is accustomed to twenty-two to twenty-three hours of daylight each summer.

BARRED OWL

The call of the barred owl *(Strix varia)* has been described as 'who cooks for you, who cooks for you'. It is a very common sound in the northeastern woodlands and the southeastern swamplands of the United States. What is not as often heard is the maniacal laughing call this bird also utters upon occasion.

The barred owl is about 24 inches (60 centimetres) in total length, has a wingspan of up to 48 inches (1.2 metres), and weighs up to 1.75 pounds (.78 kilogram). Its head is rounded, having no ear tufts, and it has large facial disks with slight barring and large brown eyes.

Although this bird is usually nocturnal, it can see well in the daylight and may even hunt on dark, misty days. Dropping from a tree perch or flying through the woods on silent wings, it feeds mainly on mice, but also catches a lot of flying squirrels, rabbits, small birds, frogs, and even an occasional fish.

Barred owls prefer to nest in large tree cavities and, fortunately for the owls, many such natural hollows can still be found in the southern swamplands. It also nests in abandoned crow and hawk nests.

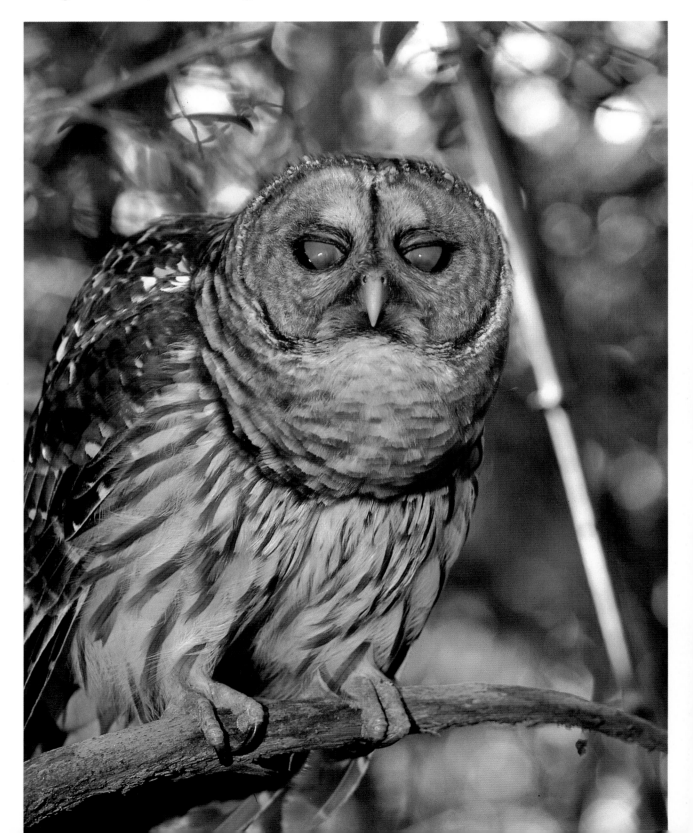

A barred owl with its protective, transparent nictitating membrane drawn across each eye. This eyelid protects the bird's eyes against twigs and the jabbing beaks of young birds.

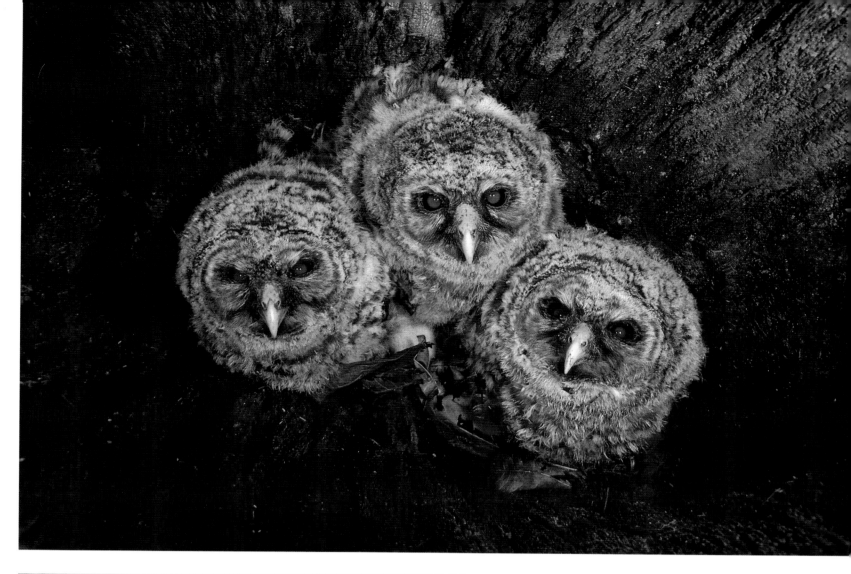

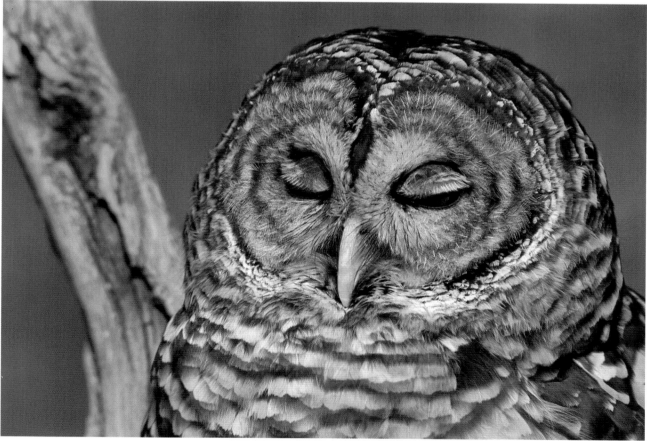

Barred owls prefer a tree cavity as a nest site whenever possible. These young owls are about one month old.

The barred owl lacks any feathered tufts on the head and so has a rounded head. It is an owl of the forests and swamps. Its mournful call, "whoo, whoo, whoooooo," is commonly heard.

BURROWING OWL

The burrowing owl *(Athene cunicularia)* is a long-legged owl that stands stiffly erect. It frequently bobs up and down. It has a wingspan of up to 24 inches (60 centimetres). The male is slightly larger than the female, which is unusual for owls. This bird has a basically tan colour with heavy barring of dark brown. It has a white patch at the throat and darts of white on its head. The eyes are large and yellow with black centres. It has a rounded head.

This owl can be found from the prairie provinces of Canada to the Gulf Coast and from the Atlantic to the Pacific in regions of grasslands and open scrublands. It migrates from the northern part of its range south to where it can find insects to feed upon.

Its primary foods are insects of all kinds, but especially grasshoppers and crickets. It hunts heavily at dusk and dawn, but also at any hour of the day or the night. It also eats small rodents, lizards, small birds, snakes, and the like.

The peaceful cohabitation of this little owl, the prairie dog, and the rattlesnake is folklore. The owls are most often found utilizing an abandoned prairie dog burrow, but they can excavate a burrow of their own. Although each will have its own territory, the owl will tolerate others of its own kind in close proximity.

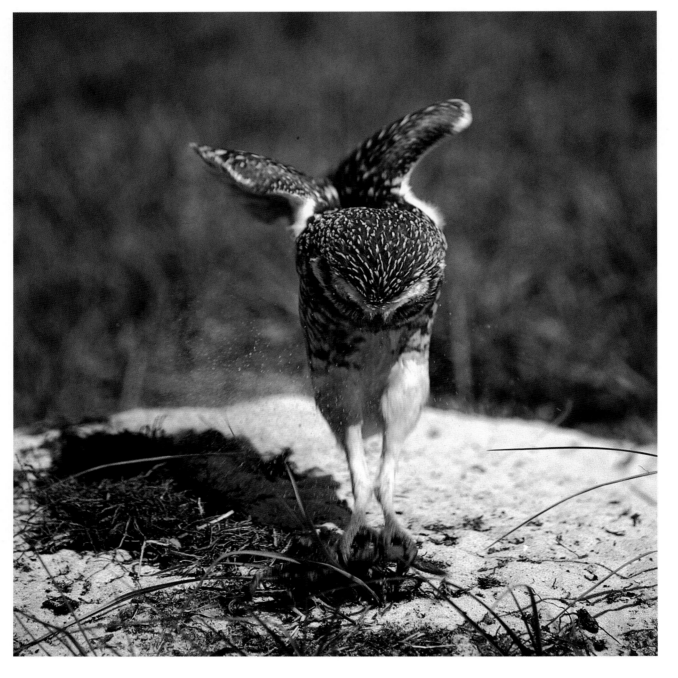

This burrowing owl is pouncing upon its insect prey. The owls usually hunt by sitting on an elevated perch, where they watch for the movement of grasshoppers, crickets, katydids, and the like.

The eyes of owls are fixed in their heads and cannot be turned, as can those of the hawks. In order to see peripherally, an owl must turn its head. This burrowing owl is checking to see what the photographer looks like vertically.

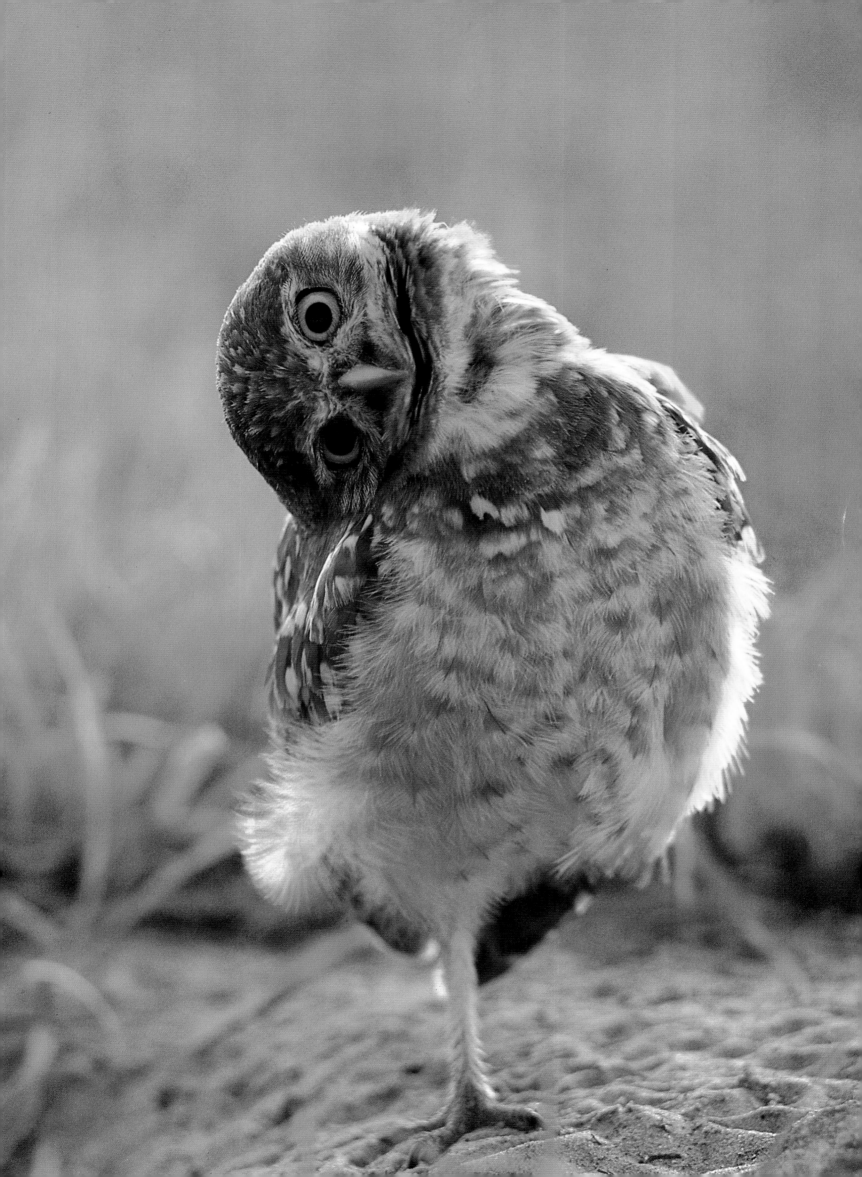

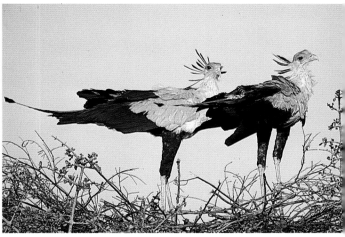

The long, stiff plumes on this bird's head reminded folks of the long quill pens that secretaries once carried behind their ears or stuck in their hair, hence its name, secretary bird.

SECRETARY BIRD

The secretary bird *(Sagittarius serpentarius)* got its name from the twenty long crest feathers that it can raise or lower as it wishes. They resemble the quill pens that secretaries used to carry behind their ears. It is a long–legged bird that stands about 48 inches (1.2 metres) high. Although it has an 84 inch (2.1–metre) wingspan and it does fly, it does not soar. The female is slightly smaller than the male.

On its long, strong legs, it strides purposefully through the grasses, searching for snakes, lizards, insects, and the like. It is estimated that the birds walk up to 20 miles (32 kilometres) per day. Its legs are heavily armoured to protect against poisonous snakebites, because this bird kills its prey by stomping on it with its feet. Its toes are short and strong.

The bird is found across all of the southern two–thirds of the African continent wherever there are plains of savannahs. It does not migrate. The birds usually hunt in pairs but, at times, five or six birds work together. They are very systematic in their hunting, walking abreast in a foraging line

Burrowing owls feed primarily at dusk and dawn, but have good daylight vision and can be seen hunting at any time of the day. They are exceptionally long-legged owls.

73

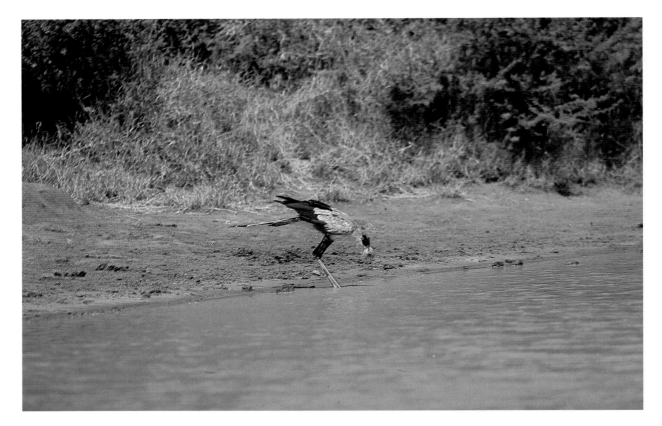

The secretary bird is the only member of a distinct bird family. The bird flies no more than it absolutely has to. It strides through the African grasslands feeding upon snakes, lizards, and insects.

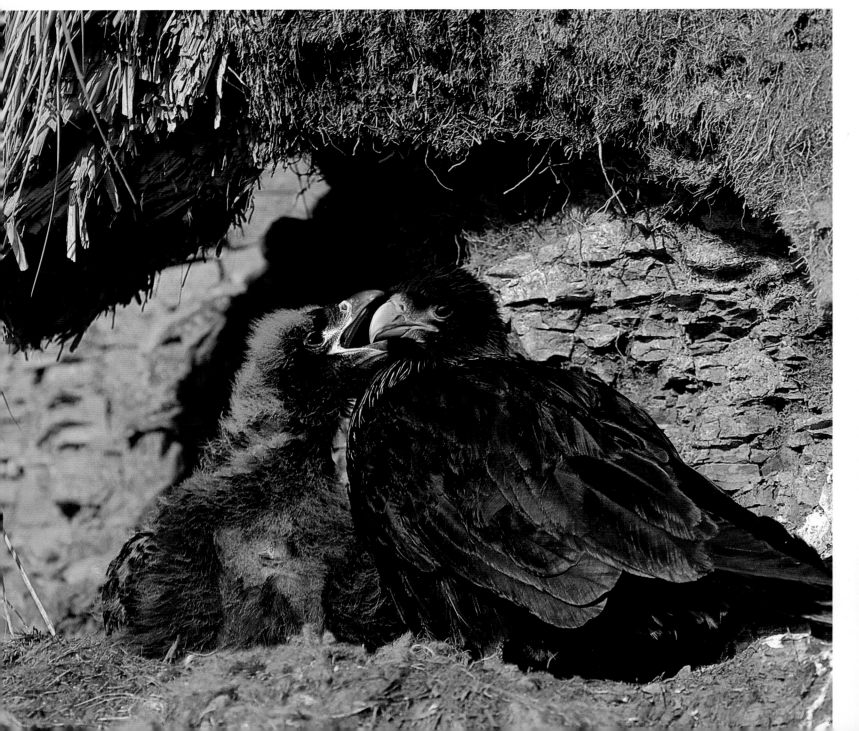

so that prey that is disturbed by one of the birds will usually be caught by the bird on either side as it tries to escape.

CRESTED CARACARA

The crested caracara *(Caracara cheriway)* is often called the Mexican eagle, as it is the national emblem of that country. It is a large bird, with a 48 inch (1.2–metre) wingspan. The bird has a black erectable crest and a bright red unfeathered face. Its legs are long and the bird spends a good portion of its time walking about on the ground, searching for insects. The bird is easily distinguishable in flight because its underwing surfaces are white on the outside portion and black on the inner portion. Both its breast and tail are white.

The birds are found over the southern tier of the United States, from Baja, California, to Florida, down into South America. Caracaras do not migrate, but may go through seasonal shifts of range, according to availability of food. They often patrol roadways to feed upon wildlife killed by cars.

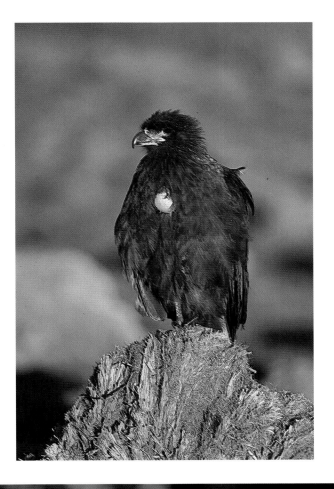

This immature striated caracara is perched on a piece of driftwood stump. Note that the bird's crop, or craw, protrudes through its feathers, a feature seen in many of the vultures.

The caracara, or Mexican eagle, is a bird found in the southern United States and old Mexico, down into South America. It feeds heavily upon carrion. The bright colouring of its face makes·it a very attractive bird, and it has very distinctive wing patterns while flying.

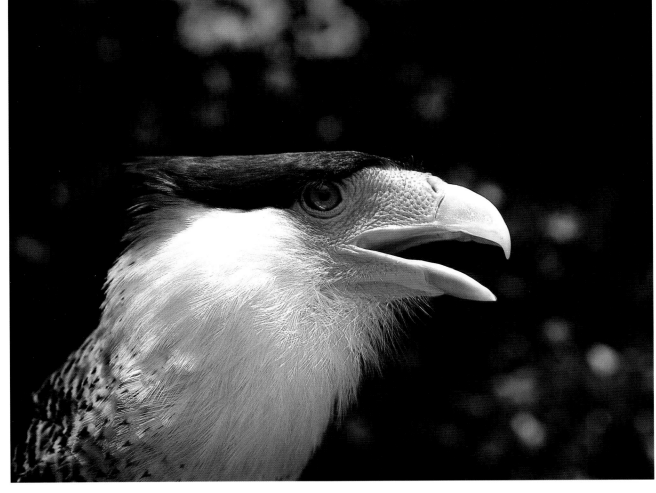

This striated caracara and baby are in their nest situated in the side of a steep bank. There are few trees in the Falkland Islands, and so the birds have adapted to nesting on the ground.

BLACK-SHOULDERED KITE

This beautifully marked kite *(Elanus caeruleus)* is found around the world south of about the thirty-second parallel. It has been observed in places as diverse as the open coastal grasslands of Texas in North America and the open brushland in the heart of Tanzania in Africa. This bird does not migrate and can be found consistently in the same areas year after year.

Its striking white head, breast, and belly contrast sharply with its slate blue back and its black shoulders and primary feathers. It has ruby red eyes, bright yellow feet, and a slightly notched tail.

This kite spends as much time searching for prey—perched in a tree, cactus, or rock—as it does flying. In flight it has the

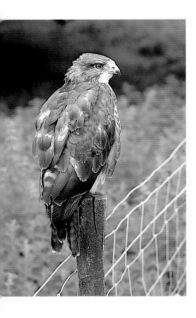

The common buzzard of Europe is a buteo, similar in size, habits, and habitat to the North American red-tailed hawk. It is usually seen perched out in the open, where it hunts for mice, voles, and other small rodents.

The black-shouldered kite is found quite commonly throughout east Africa. Unlike some of the other kites that hunt mainly while flying, this kite usually perches on some prominent tree limb or stump, from which it hunts small birds, mice, and some insects.

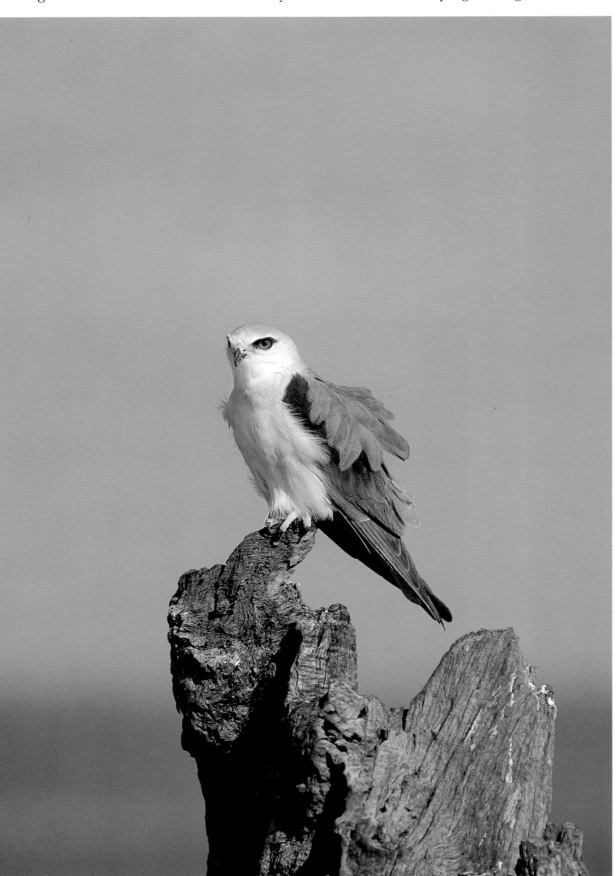

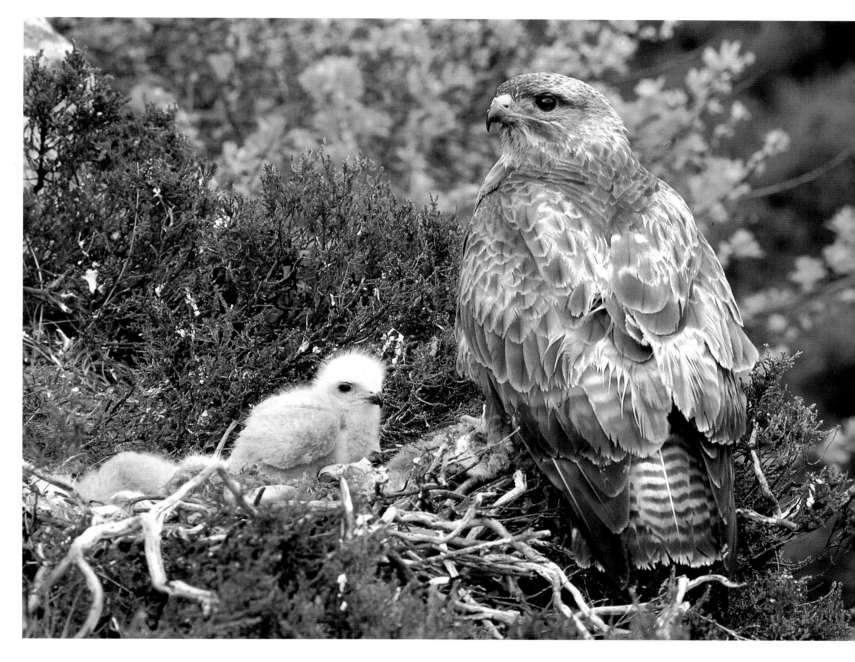

grace and beauty of all kites, dipping and twisting. Spotting a small rodent, it may hover until its prey is in a position to be caught. Rodents up to the size of a rat will be taken. It feeds on large grasshoppers and locusts, which it may catch on the ground or snatch out of the air. It occasionally takes small birds.

EURASIAN BUZZARD

The Eurasian buzzard (Buteo buteo), as its name implies, is found across Europe and Asia. It does migrate in winter to India or Africa. This buzzard is the counterpart of the red–tailed hawk that is found all across North America. It is the most commonly seen and best known of all the buteo

hawks, and, like the redtail, this buzzard also comes in different colourations, from a light tan to a dark brown, although the light to medium brown form is the one most commonly seen.

This hawk measures up to 23 inches (58 centimetres), has a wingspan of a little over 48 inches (1.2 metres), and weighs about 3 pounds (1.4 kilograms). It is a soaring hawk, flying on air thermals as it sweeps back and forth across the sky, scanning the grasslands below for some telltale sign of prey. It feeds mainly upon mice, voles, rats, squirrels, rabbits, and small birds.

When not soaring, the hawk perches on a tree limb overlooking the grassy areas. It then launches its attack and drops down

Prey that is too large for common buzzard chicks to swallow whole must be torn to pieces by the parent. Note the carcass that the birds have been feeding on.

on its prey. The population of this hawk dropped dramatically when the disease myxomatosis decimated the European rabbit population.

Although it needs the open areas to hunt for food, it nests in the woodlands and forests.

EUROPEAN SPARROWHAWK

The European sparrowhawk (*Accipiter nisus*) is often confused with the kestrel, which is a falcon. As its Latin name, *Accipiter*, implies, it is a woods hawk, with its North American counterpart being the sharp–shinned hawk. It has cupped wings that span 25 to 27 inches (63 to 68.6 centimetres). The bird's total length is 13 to 14 inches (33 to 35 centimetres) and it weighs about 6 ounces (168 grams).

This little hawk is common across all of Europe and Asia, from the Atlantic to the Pacific Oceans and from the northern tree line south to Africa.

It may hunt for its prey by remaining motionless, perched on a tree limb, hidden by the foliage, until the prey species is in an area open enough to be caught. It has a flapping–gliding style of flight. Its powerful cupped wings are flapped about four to five times to build up speed and then the bird glides until it starts to lose speed, at which time it flaps again.

Small birds, up to the size of a thrush, are its dietary mainstay. The sparrowhawk also feeds upon mice and large insects.

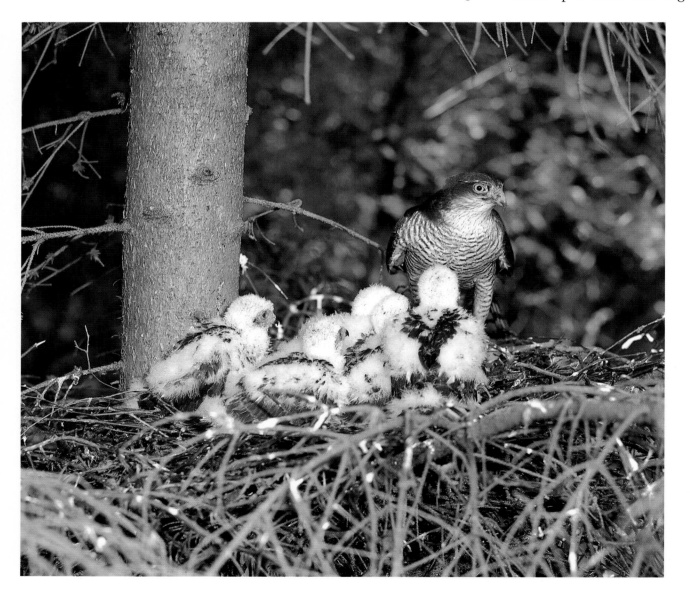

The European sparrowhawk is an accipiter, or woods hawk, while the North American sparrow hawk, or kestrel, is a true falcon. These birds hunt and live in dense woodlands. This young bird is about one month old.

A male kestrel attacks a small bird, which it will soon make into a meal.

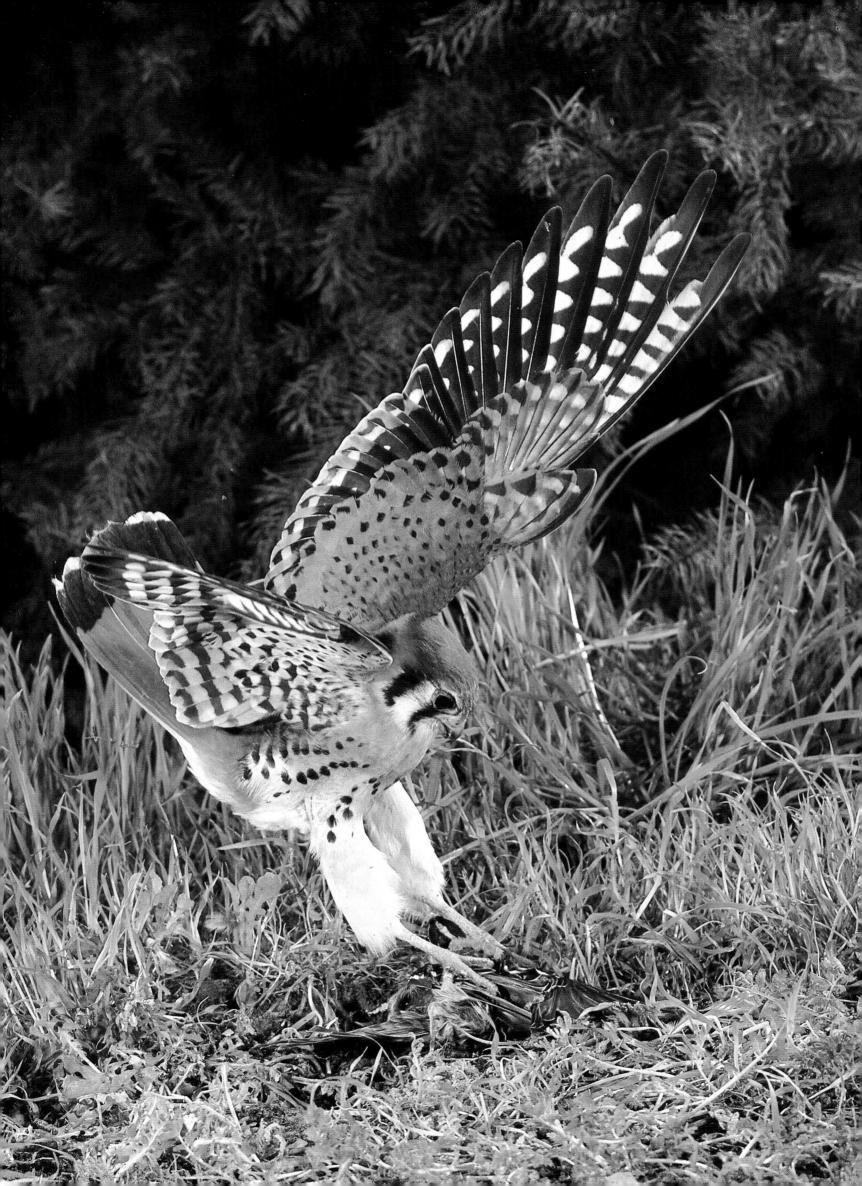

PHOTO CREDITS